Celebration

Calligraphy

Celebration

Calligraphy

Complete instructions and templates
for special-occasion alphabets,
borders, and motifs

RUTH BOOTH

BARRON'S

A QUARTO BOOK

First edition for the United States,
its territories and dependencies,
and Canada published in 2008 by
Barron's Educational Series, Inc.

All inquiries should be addressed to:
Barron's Educational Series, Inc.
250 Wireless Boulevard
Hauppauge, NY 11788
www.barronseduc.com

ISBN 13: 978-0-7641-3948-2
ISBN 10: 0-7641-3948-7

Library of Congress Control No. 2007933784

Conceived, designed, and produced by
Quarto Publishing plc
The Old Brewery
6 Blundell Street
London N7 9BH

QUA: WCA

Project editor: Michelle Pickering
Art director: Caroline Guest
Art editor: Emma Clayton
Designer: Michelle Canatella
Photographer: Phil Wilkins
Illustrators: Kuo Kang Chen, Kate Simunek,
John Woodcock

Creative director: Moira Clinch
Publisher: Paul Carslake

Color separation by Modern Age
Repro House Ltd., Hong Kong
Printed by SNP Leefung Printers Ltd., China

9 8 7 6 5 4 3 2 1

Contents

 B C D E

Introduction

Cards and invitations for almost every occasion can easily be found in many stores and online, so why bother to make your own? Artists and crafters derive great satisfaction from the creative process. They make beautiful things that are uniquely different from those found in the mass market, and their creations are a pleasure to receive.

Card making can incorporate a host of skills, or just one or two. Collage artists, photographers, calligraphers, illustrators, painters, quilters, wordsmiths, and paper crafters alike can use their skills to personalize and accent charming or elegant announcements, invite people to a celebration, or relay a heartfelt sentiment.

Hand lettering is personal, even that which is carefully practiced and performed. Unlike type, each letter relates to the next in a slightly different way, and each character that is fashioned has its own subtle nuances. A calligrapher strives for consistency in form and spacing, and it is that diligence that weaves a beautiful texture on the page. A designer or lettering artist strives for impact with the written word, but it is the rhythm of their lettering that gives it life. There is an energy captured within the strokes and rhythm of a practiced and confident hand that cannot be replicated with type. Lettering is a trail that distinguishes the hand that renders it.

Relax and allow the pen to glide gently. Get lost in the meditative rhythms of practice. A beautiful hand-lettered rendering of your own words is a lovely way to make your unique cards and invitations more personal. There is little doubt that it will warm the heart of the person who receives it.

RBook

How to use this book

The book begins with an overview of tools and materials, lettering basics, design principles, and tips for getting started. The next section, Alphabets and Motifs, features instruction for twenty hand-lettered alphabets, with borders and embellishments to accompany them and layout ideas for their use. A section of Core Techniques follows, providing step-by-step guidance on the main paper crafting techniques. Mix and match letter styles and embellishments with decorative techniques to make original cards or invitations for any occasion. For additional inspiration, there is a gallery of examples from professional calligraphers at the end of the book.

Alphabets

The twenty hand-lettered alphabets are divided into four categories: weddings, holidays, birthdays, and milestones. Each category is then subdivided into three themes, with either a monocase or lower- and uppercase alphabet for each theme.

Dominant pen angle

The dominant pen angle is the angle at which the pen is held most of the time for a calligraphic alphabet style. When the pen angle needs to be changed for certain letter strokes, this is indicated by a small box showing a different pen angle beside the relevant stroke.

Slant line

A slant line is shown at the beginning of an alphabet whenever it is written at a consistent forward slant. Slant lines have not been included for either upright alphabets or playful styles with letters that tilt forward and back.

Tools

The tools used to create the alphabet.

Distinguishing features

Each alphabet includes a description of the alphabet's shape, proportions, and characteristics, plus three labeled examples to illustrate those features.

Letter height

The little black rectangles shown at the beginning of some alphabets are pen nib widths. These are used to determine the height of calligraphic letters (see page 17).

Letter-spacing guide

This shows the appropriate spacing between different types of letter shapes (see page 15).

Letter construction

Step-by-step instructions for one or two letters are included with each alphabet to demonstrate how letter strokes fit together. Each step is shown in black, with any previous strokes in gray. Ductus arrows show the direction of the strokes.

Guideline helper

The fine lines at the left side of each alphabet are designed to help you rule accurate guidelines quickly and easily (see page 16).

Ductus

Gray arrows and numbers are shown beside each stroke of the letters on most alphabets. This is the ductus. Ductus lines are included whenever the direction and order of the strokes affects the construction of the letters. Where there are ductus lines without numbers, the direction of the stroke is still important, but the letter is made with one continuous stroke.

Borders and embellishments

Borders and embellishments are provided for each alphabet theme, although many of them could be combined successfully with other alphabets as well—adapt and use them as you wish. You can trace, photocopy, scan, or draw them freehand, or use them as inspiration to source similar aclip art images on the Internet (see resources on page 128).

Borders

These provide a decorative accent and help to focus attention on the main elements of the design. Many of the single motifs could also be adapted to create borders, and vice versa.

Frames, dividers, and corners

Use these devices to direct the eye to the main motif or lettering, or divide one section from another.

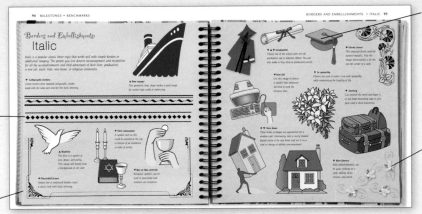

Motifs

When used large, these can form the main focal point in conjunction with the lettering. When used small, they form decorative accents or can easily be adapted into borders.

Embellishments

Remember that you can use "real" embellishments as well as drawn motifs. Wirework shapes, stick-on stars, paper flowers, and other decorative items are readily available at craft stores and on the Internet. Homemade elements or found objects can also be used.

Combining the elements

The alphabets, borders, and embellishments form the basic building blocks for creating your own cards and stationery. A selection of layout ideas is provided for each alphabet category to get you started, and there is also a section of step-by-step paper crafting techniques.

Layout ideas

Each of the four alphabet categories—weddings, holidays, birthdays, and milestones—begins with a few suggested layout ideas for combining the alphabets, borders, and embellishments. You will also find inspirational ideas in the gallery at the end of the book.

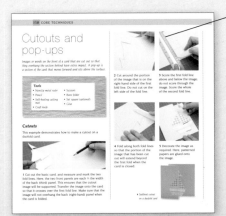

Core techniques

Refer to the concise step-by-step instructions on the core paper crafting techniques to help you achieve the best results.

Tools and materials

The main tools and materials used in this book are listed here. All can be found in most art and craft stores, and through the Internet. Archival quality is only a concern if you are making something that you hope will last for generations. Generally, cards and invitations fall into the ephemera category—something to enjoy for a short time.

For lettering

Graphite pencil

A common monoline tool with a graphite writing tip that can be sharpened to a point or used dull and rounded. Pencils are graded on a scale from H (hardness) to B (blackness). Very hard pencils (9H) lay down little graphite and are therefore lighter on the page, but may score the paper. Very soft pencils (9B) lay down more graphite and are therefore darker on the page, but smudge easily. HB indicates the middle of the range. Artist-quality graphite pencils are archival.

Colored pencil

A monoline tool that can be sharpened to a point or used rounded and dull; available in a range of qualities. Artist-quality offers the richest, most permanent, and lightfast color.

Soft white eraser

Soft, so that it will not damage the paper; white, so that it will not leave a colored residue.

Colored fine-line marker

A fine-tipped monoline tool that comes in a wide range of colors. These markers are not permanent or archival unless indicated on the label.

Fine-point permanent marker

A monoline tool that is waterproof and lightfast. These markers come in a variety of colors, but not all colors are permanent.

Pigmented fine-line marker

A monoline tool that comes in a range of fine tips. The rendered line width is shown in millimeters on the label. Most brands are permanent and archival.

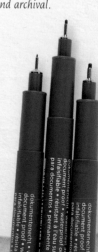

Broad-edged nib

These metal nibs come in a range of sizes and require a separate ink source. Brands differ in flexibility and reservoir design. Right-handed artists generally use square-cut nibs; left-handed artists use oblique-cut nibs. The broad-edged calligraphy alphabets in this book were done with a #2 (2-mm) Mitchell Roundhand nib.

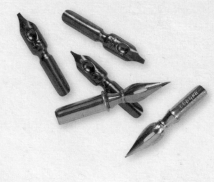

Pointed nib

This metal nib has a pointed tip and is used in a straight penholder. It comes in a range of flexibility and fineness. Considerable pressure needs to be applied to splay a stiff pointed nib, so it is used to draw lettering with little or no contrast in line weight. A flexible nib splays easily when pressure is applied, allowing more gradual transitions in line weight, but be aware that very fine lines can be problematic for reproduction.

Penholder

A plastic or wood handle to hold a pen nib. An oblique penholder has an elbow or flange that offsets the nib from the handle. A standard penholder is straight. Oblique holders are recommended for letter styles written with a severe forward slant.

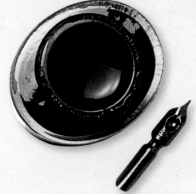

Permanent ink

A permanent carbon-based or pigmented ink. Avoid India ink and inks that have shellac in them, because they may remain sticky.

Gouache

An opaque, water-based, pigmented paint that comes in a wide range of colors; quality varies from one brand to another. Artist- and designer-quality gouache are easier to write with, because they have less filler and more finely ground pigment. If longevity is a concern, choose colors with the highest permanence rating. To use in a pen nib, thin ¼ teaspoon of paint with a few drops of water. The manufacturer adds a small amount of yellow liquid (glycerine) to the top of each tube of gouache. This is to keep the paint moist and extend its shelf life. Remove and discard this liquid before mixing the paint.

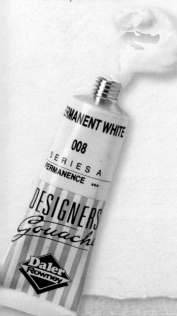

Alternative lettering tools

The alphabets in this book are shown at actual size. Each alphabet includes a list of the tools used to create it. If you use the writing tools listed, letter at the size shown, and follow the instructions, you can achieve similar results. However, there are many alternative tools readily available that you may wish to try, such as calligraphy markers, fountain pens, and brush markers. If you use an alternative tool, the results may still be pleasing, but they will differ from the model.

For paper crafting

Tracing paper
Lightweight, translucent paper; useful for determining layout and the positioning of elements in a design, as well as to transfer images.

Bond paper
Text-weight paper, commonly used for photocopies, that is ideal for roughs, mock-ups, and cover sheets (used to protect good papers when folding). Many manufacturers now produce this paper in solid colors, with coordinated patterns or decorative borders. These papers are easy to fold and cut, and they work well for layering and collage, but they do not have enough body to be used alone as the primary card structure.

Japanese and handmade papers
Quality papers and tissues imported from Japan look delicate, but they are quite strong. They fold nicely, layer beautifully, and produce a feathery edge when torn. There are also many other types of handmade papers that are strong, textured, and come in beautiful colors.

Scissors
Sharp, pointed scissors are handy for quickly cutting paper elements. Paper blunts scissors very quickly, so use a different pair for cutting fabric. Scissors with scalloped or zigzag blades are useful for cutting decorative edges.

Craft knife
A sharp cutting tool with a pointed tip and convenient break-off blades. An X-acto knife or scalpel are useful alternatives and have longer lasting blades.

Card stock
This paper is a little heavier than bond paper and comes in a wide variety of colors. It folds well when scored, and has enough body for use as the primary card structure.

Artist's paintbrushes
Synthetic paintbrushes in a small, medium, and large size are sufficient for most purposes.

Watercolor and art papers
Watercolor papers are the best choice for wet media, because they will not break down or buckle. They come in three finishes: Hotpress—a fairly smooth surface that is good for lettering; Coldpress—a rougher surface that is more difficult to letter on; and Rough—not appropriate for traditional lettering. Watercolor paper also comes in several weights; 90-lb (40-kg) paper is heavy enough for card structure, folds well when scored, and is a good weight for embossing. There are some lovely art papers with textured surfaces intended for charcoal and pastels. These are heavier than bond paper, and work very well for embossing and card structure.

Nonslip metal ruler

A nonslip metal ruler makes accurate measuring easier, because it will not slip.

Bone folder

Use the tapered point to score paper, and the straight edge to make clean, sharp folds. The traditional folder is made from bone, but Teflon and plastic versions are also available.

Self-healing cutting mat

A convenient cutting surface that does not disintegrate and will not dull your cutting blades. A measuring grid is printed on the mat, which comes in a range of sizes.

Glue

A good-quality fabric/paper glue stick is the most useful for paper crafts. A strong all-purpose adhesive will stick to most other materials, and craft glue (PVA) is useful because it dries transparent.

Removable tape and other adhesives

Removable tape, also known as drafting tape, will hold your work in place and can be removed without damaging the paper. Double-sided adhesive tapes, tabs, and sheets are a fast and clean way to apply adhesive to cards and attach layers securely. Foam mounting tape and tabs add another dimension by raising elements above the card surface.

Punches

Punches are available in a variety of shapes and sizes and are used to cut shapes from paper or card stock.

Rubber stamps

There is an incredible selection of rubber stamps available, and there are even stamps that fit onto a special roller for long images. Alternately, you can cut your own stamps from white eraser or artist's cutting blocks.

Embossing tool

A tool with a stainless steel shaft and a ball end that is used to impress a design into card stock. Double-ended tools have two different-sized ball ends. Embossing templates are widely available, or make your own with 2-ply Bristol board.

Set square

A triangular piece of transparent plastic with a 90-degree angle, useful for drawing lines at 90 degrees or cutting square corners. Use a metal-edged set square for cutting against.

Embossing powder and heat gun

Available in a variety of colors and metallic finishes, this powder adheres to wet ink and melts to a shiny raised finish when heat from a heat gun is applied.

3D embellishments

There are numerous readymade embellishments available, from beads to ribbons. Found objects, such as pressed leaves, can also be used.

Wet media

Watercolor is water-soluble pigmented transparent color. Quality varies from brand to brand, but most are not lightfast. Watercolor is also available in pencil form. Acrylic ink is a vivid liquid color that is permanent when dry. Most brands are also lightfast.

Inkpads

These can be dye- or pigment-based, and come in a huge selection of colors. Pigmented inks are more opaque and have a longer drying time that is convenient for wet embossing.

Lettering basics

Hand lettering done well is consistent. Even alphabets that look spontaneous have characteristics that are constant. The letters within an alphabet family need to share a number of characteristics in order to look like they belong together. The glossary on pages 124–125 provides concise explanations of the main terminology used.

Distinguishing features

Distinguishing features describe the characteristics of each alphabet. A grouping of consistent text is a strong element within a composition or design. Here are the primary characteristics to be mindful of when lettering.

Line weight—broad-edged nib

The line weight of alphabets made with a broad-edged nib is determined by the pen angle used and the height of the body of the letter relative to the width of the pen nib.

Line weight—pointed nib

The line weight of the downstroke of alphabets made with a pointed nib depends on how much pressure is put on the nib to make it splay.

Entry stroke and exit stroke

Be conscious of the serifs, or pen marks, made at the beginning and end of each letter.

Bowl shape

Bowls can be round, angular, oval, and so on.

Branching

The branching stroke that springs from a downstroke can occur nearer to the baseline or nearer to the top of the x-height.

Counter space(s)

The size and shape of the negative space(s) within the letter shape.

Letter width

The body of a letter could be as wide as it is tall. Narrow letters can look dense on the page because the downstrokes are close together.

Slant

Traditional alphabets have a very consistent forward slant or no slant at all. Slant continually varies with some modern alphabets.

Letter spacing

Lettering creates texture on the page. Your lettering will be more pleasing, easier to read, and create a more attractive texture if it is spaced appropriately. Spacing is consistent when the distance between letters appears to be the same as the spaces inside the letters. The downstrokes of the text reveal a rhythm when confident, well-spaced letters are written consistently.

Letter-spacing guide

The letter-spacing guide has been designed to help you see the appropriate spaces between letters more easily, while giving a visual impression of a word written in each alphabet style. Alphabets with letters of consistent proportion and shape, such as Copperplate (pages 26–27), need to be spaced evenly so that distracting dark areas or white holes are not created within the texture of the lettering. A standard-sized blue spacer is used to indicate the required spacing. This is either about the same size as the counter space in the n, or equal to the most difficult letter-spacing combination. Uneven spacing is more appropriate for alphabets with inconsistent letter shapes and sizes, such as Junior (pages 62–63).

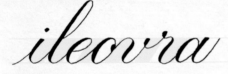

Copperplate

Alphabets with consistent proportions and shapes require even spacing, indicated by the blue spacer.

Junior

Alphabets with inconsistent proportions and shapes can have uneven spacing.

Letter types

The letters featured in the letter-spacing guide have been chosen to demonstrate the relationships between a variety of letter types: straight-sided letters (il), straight and round (lo), round and round (oe), open and diagonal (ev), diagonal and straight (vr), open and round or open (ra). In order to achieve letter spacing that looks reasonably consistent, we need to determine visually where the letter ends and the space between the letters begins. Our eye tends to borrow a portion of the space surrounding round and diagonal letters, as well as space from within open letters, and then adds it to the space between the letters. That is why the blue spacer boxes sometimes overlap a portion of the letters.

Pen angle

The appearance of letters made with a broad-edged nib is affected by the pen angle. Try this exercise to help you gain a clear understanding of how the pen angle affects the weight of the stroke. Make four copies of this series of lines and a circle. On the first copy, use a flat (0-degree) pen angle to trace over each of the lines and the circle. Make sure that you maintain a flat pen angle throughout all strokes. Use two strokes for the circle. Repeat using a 20-, 45-, and 60-degree pen angle. Be sure to maintain each pen angle throughout each series. Compare the four samples. Note where the strokes are heaviest and thinnest in each series; note where the strokes are thickest on the O of each series.

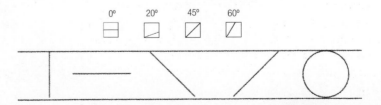

Using the guideline helper

Each alphabet has its own customized guideline helper. When working at the same size as the exemplar and with the specified tools, use the guideline helper to rule appropriate guidelines for your lettering.

1 Position a strip of paper over the exemplar so that the right edge reveals the guideline helper and the top is aligned with the top edge of the book page. Make a dot on the right edge of the paper to mark the position of each guideline. Mark the first baseline with a star. Label this guideline master with the alphabet name for future use.

2 When making a card or practice sheet, determine where the first line of lettering will go and use an H or 2H pencil to rule a baseline. If you want the lettering to be square on the page, measure and mark the distance from the top of the card in three places to be sure the baseline that you rule is accurate.

3 Align the guideline master with one edge of the card so that the first baseline mark indicated on the master aligns with the baseline drawn on the card. If there is no straight edge to align the master against, use a pencil to rule two vertical reference lines at 90 degrees to the baseline and as far apart as the card or practice sheet will allow. Make a dot on the card or practice sheet beside each dot on the guideline master.

4 Align the guideline master with the other edge of the card and mark each guideline with a dot.

5 Use a nonslip metal ruler and pencil to rule guidelines by connecting the dots.

Color coding

The guideline helper is color coded to help you see at a glance which lines are which. The baseline is black; the x-height is pink; and the ascender/descender line is orange.

Adjusting the letter height

The relationship between the pen nib width and the letter height has a significant impact on the appearance of a calligraphic letter style, while monoline and drawn alphabets can be adapted to different sizes fairly easily, often with the same tool.

Calligraphic alphabets

When lettering a calligraphic alphabet at a different size, you must use a different-sized pen nib. The x-height, ascenders, and descenders are measured in nib widths. An alphabet with an x-height of 4 nib widths will be smaller when written with a narrower nib and larger when written with a wider nib, but the alphabet's proportions will remain the same. When using a nib size that is different from the size used for the exemplar, use the following method to determine the new letter proportions.

1 *Refer to the alphabet to see how many nib widths the x-height, ascenders, and descenders should be. On a piece of scrap paper, draw a baseline. Position the pen so that the width of the nib is at 90 degrees to the baseline. Pull a short horizontal line along the baseline; it will look like a small box. In order to achieve accurate results, it is important to position the pen nib accurately and pull short straight boxes at 90 degrees to the baseline.*

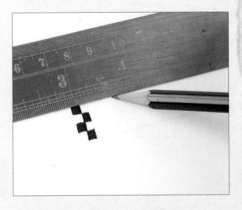

Monoline and drawn alphabets

When adapting monoline and drawn alphabets to different sizes using the same tool, just be sure to maintain the same letter proportions. If the alphabet has ascenders and descenders that are the same length as its x-height, they should remain the same as the x-height when the lettering is done at a different size. A significant change in alphabet size may require a finer or thicker writing tool.

2 *Maintain the 90-degree pen angle and make another little box, making sure that the bottom edge of this box aligns with the top edge of the previous box. Repeat this process until you have the correct number of nib widths, staggering the boxes so that you can count them easily.*

3 *Once the ink is dry, rule a parallel guideline at the top of the staggered stack of nib widths. The distance between these two lines is the new x-height. Determine the ascender and descender heights using the same method.*

Design principles

Social announcements, requests, and expressions of goodwill in the form of cards and invitations have become ingrained in the culture of our society. They are small compositions. Carefully designed and made, they are a kind and thoughtful gift to be treasured.

Elements of composition

Consider the balance, contrast, dominance, and unity of elements within the composition. An element can be a single word, grouping of words, an image, motif, or embellishment.

Balance

This refers to the sense of stability created by the distribution of weight and space. The weight of an element is determined by its relative size and tone (how light or dark it is). The spaces within and around the composition should never be underestimated. They are as powerful as the other elements in the design.

Unity

This is achieved by relating the design elements to each other, and to the idea or sentiment being expressed. These relationships can be reinforced using shape, color, texture, line quality, or direction. For example, muted colors are quiet; bright colors are bold. A text block could be justified around the shape of the illustration. Horizontal lines suggest calm. A horizontal format can be echoed by long lines of horizontal text or a border that runs across the bottom of the card. A small patch of bright color in an element can be restated with layered paper.

Dominance

In any composition where there is more than one element, an order of importance among the elements must be determined. It should be clear to the observer where to look first.

Explore your options

Sometimes a little "playtime" pays off. Try a variety of layouts. Consider writing on a different card stock or paper, tear around your lettering, and adhere that to your cards. Experiment with other lettering styles or try using a different tool or color. Experiment with media and techniques. Not only will you become more proficient, but you may discover new methods or effects. Do roughs and make mock-ups before beginning the final project.

Contrast

Contrast adds interest to a composition and can be attained by varying the weight, texture, color, size, or direction of the elements. Contrast can be achieved with text alone. Too many contrasting elements will look chaotic.

Designing for reproduction

Familiarity with computer equipment makes it easy to produce multiple copies of cards or invitations. In order to use your own lettering and combine it with illustration, you will need access to a scanner and a printer. A layout program such as InDesign, QuarkXPress, or Publisher can be helpful, but Photoshop and Microsoft Word are also very useful. You may want to access the Internet for clip art images or specialty paper supplies.

Printer limitations

Be aware of the minimum and maximum paper sizes your printer can accommodate. Many printers cannot print right to the edges of the paper. Design your card so that all the printed elements fit within those margins. If you can only print in black, consider printing on a decorative paper or the addition of three-dimensional embellishments.

Do lots of planning

Make a mock-up to plan the location of folds and determine which side of the paper the elements should be printed on. Confirm the positions of the elements by printing a test sample on less expensive paper of the correct size. Once you are happy with the placement, run a test copy on the "good" paper to test that it will go through the printer and take the printer ink well.

Consider the materials

Make sure that you have extra paper for testing and reprints. Plan the invitation or card to fit an envelope size that is readily available. Avoid materials that may be too bulky or become damaged when they go through the mail. Check the limitations and rates for postal mail in your region. Most postal systems have standards posted on their Web site. There may be some limitations, and extra postage is often required for oversized or odd-sized mail.

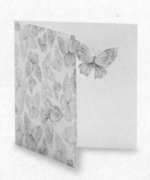

Simplify

Do not get in too deep. Often simple designs with quality materials and good lettering are all you need. Think twice about using techniques such as cutouts or embossing in large quantity, because this can be very time-consuming.

Work bigger and reduce

Hand lettering often benefits from being reduced. Work at a comfortable size, scan it into the computer, and then reduce the size of the text. Fine lines and serifs may get lost with significant reduction, so testing is advisable. Photocopiers can also be used to reduce lettering and print cards or invitations.

Getting started

There are some simple things you can do to ensure a more comfortable and successful creative experience.

Work surface

Use a slanted surface or lapboard when lettering to help avoid back strain. A flat, sturdy board about 18 x 24 inches (45 x 60 cm) will work well. Sit in a chair at a table with your back straight. Rest one end of the board in your lap and lean it against the edge of the table. Adjust the angle of the board by moving your chair closer to or farther from the table. For paper crafting, use a large flat surface that is at a comfortable height for you. If you prefer to stand when cutting, gluing, and designing, try raising the table by putting blocks under the table legs so that you do not have to bend over for long periods of time.

Protect your paper

The moisture and oils from your hand may leave a residue on the paper that will repel writing fluid. To protect the paper, you can either keep a piece of scrap paper under your hand as you write or wear a hand guard. To make a hand guard, simply cut the ribbed end off an old sock and snip a small thumb hole in it about 1–2 inches (2.5–5 cm) from the end. Wear the hand guard on your writing hand whenever you are lettering.

Good lighting

Work in a well-lit area. Good lighting will limit eyestrain and help you to work more accurately. Natural light is best, but bright light from an overhead source is also very helpful.

Padding

Work on a padded surface. Tape several layers of clean scrap paper to the lapboard or work surface. This padding helps ensure that you do not transfer unwanted textures from the work surface to the lettering. It also compensates for slightly uneven pressure when working with a calligraphy pen and when rubber stamping.

Test your tools

Always have an extra piece of the same paper or card stock you will be working on so that you can test your tools. Markers will bleed on some papers, and certain colors will not show up very well on dark or brightly colored background papers. Ensure that the flow of writing fluid from the pen nib is controlled and consistent.

Use guidelines—most of the time

Even a very experienced calligrapher uses guidelines for formal work. Take the time to ensure that your lines are straight and parallel to the top and bottom of the card. The guideline helpers are useful when you are lettering at the same size shown on the exemplar (see page 16). Rule them very lightly with an H or 2H pencil so that they can be erased easily. Once you are confident with less formal styles, you may want to try using only a baseline or working freestyle. This adds more life to the work of an experienced lettering artist. Ensure that lettering has dried thoroughly before attempting to erase guidelines. A drop of gum arabic can be added to thinned gouache to make sure that the lettering does not move when guidelines are erased.

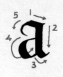 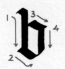 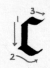

Do a rough draft

It is always advisable to write out the wording on a piece of scrap paper, at the same size and with the writing tool you intend to use for the finished work. Ensure that the placement, spacing, size, and layout will work before you begin writing on the finished card. Practice more complicated letter forms over a period of time before using them in your paper crafts.

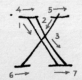 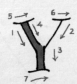

Tip

Cover the work area and floor with inexpensive plastic drop sheets when working with wet media. This will give you the freedom to play without concern about splashes. Keep a fresh container of moist wipes nearby to clean your hands.

Adam

Birgitta

Antonio

Matthæus

Nicholas

Alphabets & Motifs

This chapter features twenty occasion-appropriate alphabets suitable for weddings, holidays, birthdays, and milestone occasions. There is also a variety of border and embellishment ideas to accompany the alphabets and layout suggestions for combining all the elements.

Weddings

Personalize a card with wishes of love and happiness for newlyweds, or find inspiration for wedding invitations and stationery. Use the layout ideas opposite as a starting place for a range of wedding themes, from casual to formal. The Milestone alphabets at the end of this chapter could also be considered for wedding invitations or cards.

Copperplate frame with centered lettering printed in classic black on ivory card stock.

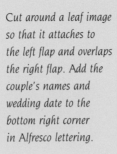

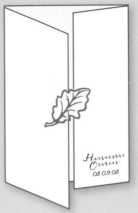

Cut around a leaf image so that it attaches to the left flap and overlaps the right flap. Add the couple's names and wedding date to the bottom right corner in Alfresco lettering.

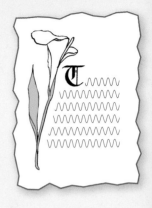

Decal- or torn-edged card stock with a calla lily down the left border. The left edge of the Gothic text follows the shape of the image.

Translucent vellum printed with Copperplate text layered over a black-and-white image of the couple, with a slightly larger piece of black card stock at the back. The three sheets are held together with grommets.

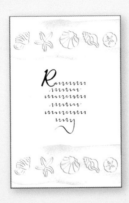

Centered Alfresco lettering is accented by a shell border on a soft watercolor background above and below.

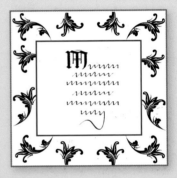

White paper with Gothic text and a fine red border is fixed to a black-on-white filigree background sheet.

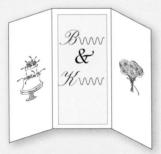

Duofold card made from delicate handmade Japanese paper, holding a complementary colored paper inside with Copperplate text. A large ampersand links the couple's names.

The wedding date is on the front flap beneath a window revealing watercolor butterflies inside. The front flap extends far enough to hide the rest of the butterflies, but leaves the Alfresco text exposed.

Print Gothic lettering on neutral-colored paper and layer it over a decorative paper. Fold the decorative paper over the top and fasten the two sheets with a complementary colored ribbon, tied with a knot.

Alphabet 1:

Copperplate

Also called Engraver's Script or English Script, this rhythmic alphabet is recognized as the traditional wedding script. Cursive letter shapes and long ascenders and descenders make it both luxurious and legible. Use Copperplate capitals (pages 28–29) as the uppercase letters for this alphabet.

Tools

- Flexible pointed nib
- Oblique penholder
- Permanent ink

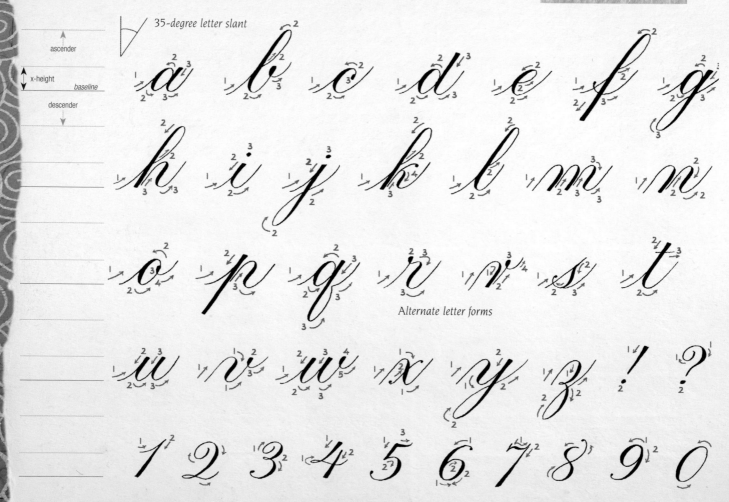

35-degree letter slant

ascender

x-height

baseline

descender

Alternate letter forms

*Where there are no ductus numbers, the character is completed without pen lifts or pauses.

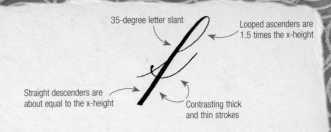

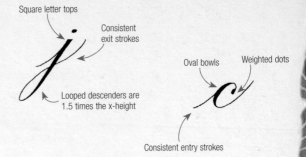

Distinguishing Features

These oval letters are made at a 35-degree slant. The alphabet has both looped and square-ended ascenders and descenders. Hairlines are made on upstrokes without applying any pressure to the nib. Shaded lines are downstrokes made by applying pressure to splay the nib. To transition between hairline and shaded strokes, gradually add or release pressure on the nib as you turn a curve, so that the transition occurs at the center of the curve. Weighted dots should rest on or under the hairline.

Letter Construction

1 Begin at the baseline and pull a hairline slightly off-slant to about ¾ x-height.

2 Starting at the top of the x-height and slightly right of stroke 1, pull up toward the top guide to form the right side of the loop. As you turn the top of the loop, begin to add pressure to the nib and make a weighted downstroke at a 35-degree slant. Stop at the baseline and release pressure before lifting the nib.

3 Place the nib just above the baseline to the right of stroke 2. Pull a hairline parallel to the downstroke and then branch to the right, curving slightly over the top of the x-height. End with a weighted dot attached to the underside of the hairline.

4 Place the nib on stroke 3, at about ⅔ x-height. Move slightly upward and then turn and make a short weighted downstroke, before curving up to the x-height with a hairline.

1 Begin at the baseline and pull a hairline slightly off-slant to about ⅔ x-height.

2 Starting at about ⅔ x-height, curve up to the guideline, then add pressure as you round the top to make an oval on a 35-degree slant. Release pressure as you approach the baseline, then pull the hairline back up until the oval is almost closed.

3 Place the nib at the x-height in line with the right edge of the oval. Add pressure to create a square top, then pull the downstroke with a 35-degree slant. Release pressure at the bottom curve, then continue the hairline up to the x-height.

Letter Spacing

ileovra

All letters are joined by hairline strokes. The spaces between the letters are the same width as the counter spaces.

Alphabet 2:

Copperplate capitals

Tools

• Flexible pointed nib

• Oblique penholder

• Permanent ink

These elegant capitals are not intended for use on their own, but to adorn the lowercase Copperplate alphabet (pages 26–27). Their generous oval flourishes and contrasting line weights capture the eye and invite readers to share in the splendid news. The luxurious, romantic curves make this style of lettering very popular among brides.

35-degree letter slant

letter height

baseline

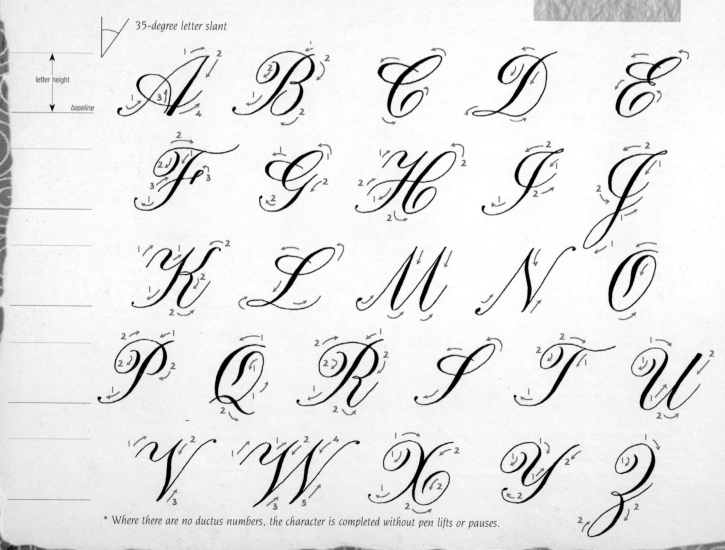

* Where there are no ductus numbers, the character is completed without pen lifts or pauses.

Distinguishing Features

These letters are made with a graceful 35-degree slant. The weighted serpentine downstroke provides the backbone for the alphabet, and the oval flourishes require lots of air inside them in order to attract the eye without trapping it. Weighted dots provide a definitive beginning for hairline upstrokes, and they also complete the hairline ending for serpentine downstrokes.

Contrasting thick and thin strokes

Serpentine curves

Capitals are 2.5 times the lowercase x-height

Oval bowls

Large oval flourish

35-degree letter slant

Weighted dot

Graceful curves

Letter Construction

1 Place the nib at about ¾ letter height and make an oval flourish. Add pressure as you move left and around, and release pressure as you turn the bottom curve.

2 Continue the hairline up to the top guideline and add pressure as you move over the top loop and down on a 35-degree slant, cutting through the flourish. Begin to release pressure at about ½ letter height, and curve back up from the baseline with a hairline.

3 Continue the hairline upward on the slant and turn an oval to the left, adding pressure as you move downward. End a little above the bottom of the letter.

1 Begin by making a weighted dot a little above the baseline, and then curl down to the baseline and back up, following a 35-degree slant. Stop just as you pierce the top guideline.

2 Briefly retrace stroke 1 and pull downward, straighter than the slant line. Gradually add weight and then release it as you approach the baseline. Curve back up with a hairline stroke, following the slant line until you pierce the top guideline.

3 Repeat stroke 2, rounding the bottom at the baseline and curling back up to the top of the x-height with a hairline stroke.

Letter Spacing

The space between capital and lowercase letters is about the same as the counter space within the lowercase n.

Borders and Embellishments:
Copperplate

A simple embossed image or exotic layered papers will complement this alphabet beautifully, or you can personalize invitations with cameo images, motifs, or large initials. The same images can be added to response cards, place cards, and thank you notes for a unified look throughout your wedding stationery.

▲ Champagne glasses
This kind of image can be used at a smaller size to separate ceremony from reception information or to decorate the envelope and R.S.V.P.

▼ Delicate borders
Delicate borders are easy to draw by hand. Use simple flowers or graceful heart shapes.

▼ ▶ Flourishes
Gracefully flourished frames and dividers are a lovely accompaniment for Copperplate lettering.

◀ **Wedding bells corner**

Wedding bells can be used instead of a bow or knot in a corner ribbon.

▶ **Calla lily corner**

Calla lilies are an elegant choice. They can be adapted for embossing or highlighted with soft color.

◀ **Wedding cake**

You could add another layer or two, and vary the color scheme of the decoration to match the wedding scheme.

▼▲ **Bouquets**

Flowers are a beautiful wedding tradition. Match the flowers to the wedding's color theme.

▶ **First dance**

Most clip art Web sites have black and white images similar to this one. Add your own color digitally or use watercolor for a softer look.

▼▶ **Wedding rings**

Use a wedding ring motif on its own, or combine rings with other elements to make a stronger motif or divider.

▶ **Wedding confetti**

Wedding confetti is widely available and can be glued to cards as embellishments.

Alphabet 3:

Alfresco

Some of these letters join together but some do not, echoing the rhythm of handwriting. The alphabet's semi-cursive nature makes it appropriate for semiformal wedding invitations, while the forward slant and long ascenders and descenders convey modest formality. Use Alfresco capitals (pages 34–35) as the uppercase letters for this alphabet.

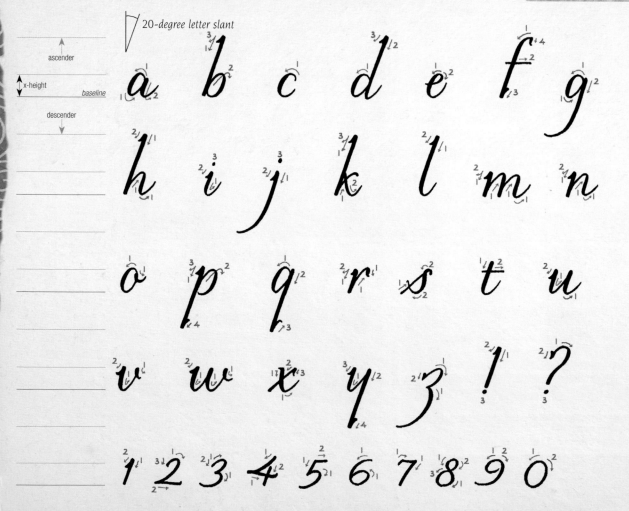

20-degree letter slant

ascender
x-height baseline
descender

Distinguishing Features

Create thick lines by applying pressure to the nib; release the pressure for thin lines. Long ascenders and descenders are 2.5 times the x-height and require constant pressure to maintain consistent line weights. Some letters have thin joining strokes, while b, f, r, s, and all those with descenders do not. A small, pulled serif adorns the top of each downstroke, while straight descenders have a short stroke added to weight the foot. Letters are oval and branch at the middle of the x-height.

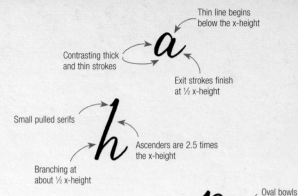

Thin line begins below the x-height

Contrasting thick and thin strokes

Exit strokes finish at ½ x-height

Small pulled serifs

Ascenders are 2.5 times the x-height

Branching at about ½ x-height

Oval bowls

Descenders are 2.5 times the x-height

Some downstrokes are weighted at the bottom

Letter Construction

o d d

1 Begin a little below the top of the x-height and add pressure to the nib as you move up and over the top curve. Release pressure just before the bottom curve and continue with a thin line until the oval is almost closed.

2 Apply pressure on the nib and then make the downstroke; release pressure just before the baseline and bounce back upward, creating a thin joining stroke.

3 Overlap the top of stroke 2 and add pressure to the nib. Pull left and quickly release pressure to create a short serif.

v y y y

1 Place the nib at the x-height guideline; apply pressure and then begin the stroke. Release pressure just above the baseline; bounce up, continuing the thin line almost to the top of the x-height.

2 Place the nib slightly below the x-height guideline; apply pressure and then make a downstroke, maintaining pressure for the length of the descender. Release pressure before lifting the nib.

3 Position the nib just above and to the right of the end of the descender; apply pressure and then pull a short curved stroke, overlapping the bottom of stroke 2.

4 Overlap the top of stroke 1 and add pressure to the nib. Pull left and quickly release pressure to create a short serif.

Letter Spacing

iloevra

The spaces between letters are about the same as the counter space within the n. There are no joining lines immediately after b, f, r, s, or letters with descenders.

Alphabet 4:

Alfresco capitals

Graceful lines and curved serifs instill a sense of gentle breezes, while weighted feet and consistent line weights keep the letters safely anchored. These gentle, flowing uppercase letters are not intended for independent use, but to accent and accompany the lowercase Alfresco alphabet (pages 32–33) on invitations, announcements, and cards.

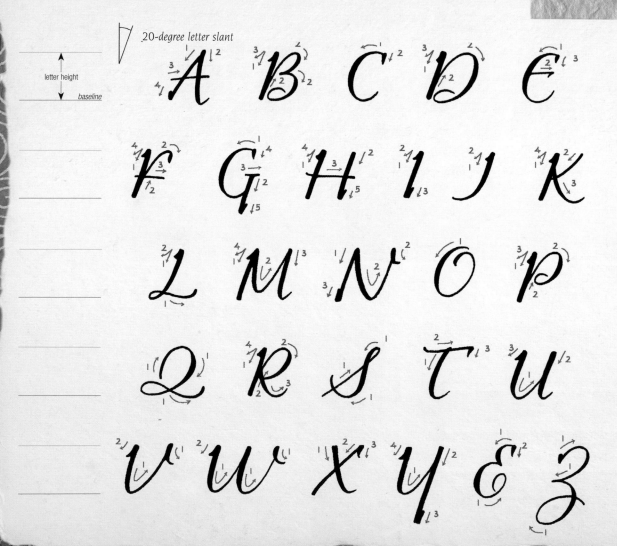

20-degree letter slant

letter height

baseline

Distinguishing Features

Create thick and thin lines using the same pressure-and-release technique that you would employ with a flexible nib, but note that more pressure is required to splay a stiff nib for thick lines, and thin lines are not as delicate. The serifs at the top of the verticals are pulled from the wet ink with short, pressurized strokes. For most downstrokes, pressure should be released before lifting the pen, but tapered exit strokes are made with a quick release of the pen. A small stroke is added at the foot of A, G, I, N, and Y to give weight. Branched strokes begin within the vertical and exit at about mid-height.

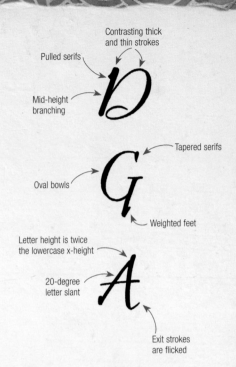

Contrasting thick and thin strokes

Pulled serifs

Mid-height branching

Tapered serifs

Oval bowls

Weighted feet

Letter height is twice the lowercase x-height

20-degree letter slant

Exit strokes are flicked

Letter Spacing

The space between capital and lowercase letters is about the same as the counter space within the lowercase n.

Letter Construction

1 Put pressure on the nib to splay the tip, then form the vertical stroke, maintaining pressure throughout.

2 Apply pressure and then curve the stroke very slightly; end by overlapping stroke 1, just below mid-height.

3 Put pressure on the nib and then begin by overlapping stroke 1 just above mid-height. Drop slightly below the baseline, then flick up and to the right, tapering the end.

4 Overlapping the top of stroke 1, put pressure on the nib and make a short curved serif.

1 Put pressure on the nib to splay the tip, then maintain pressure to form the vertical stroke.

2 Overlapping the top of stroke 1, apply pressure and begin stroke 2. At about ¼ letter height, begin to release pressure, make a soft turn, and bring the stroke back up to the top.

3 Apply pressure on the nib and maintain it until just before the baseline; release, flicking up and to the right.

4 Overlapping the top of stroke 1, apply pressure and make a short curved serif.

Borders and Embellishments:
Alfresco

Outdoor weddings can be held on the beach, in the wilderness, or in a park or garden, but you do not have to have an outdoor wedding to use images from nature. A wide variety of motifs are offered here, from simple hand-drawn grasses to a traditional grapevine border.

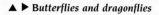

▼ Outdoor motif borders

Nature can be an endless source of inspiration. Use simple images as dividers, or repeat to create a border that runs all the way around the invitation or card.

▲ ▶ Butterflies and dragonflies

Favorites like these can be grouped to decorate a corner or strung in a row to make a delicate border.

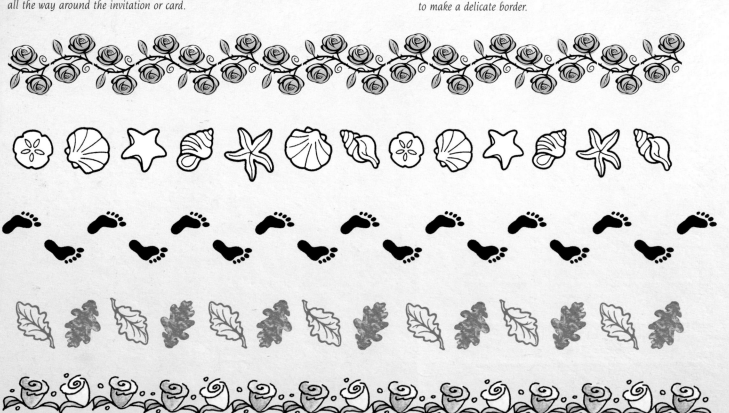

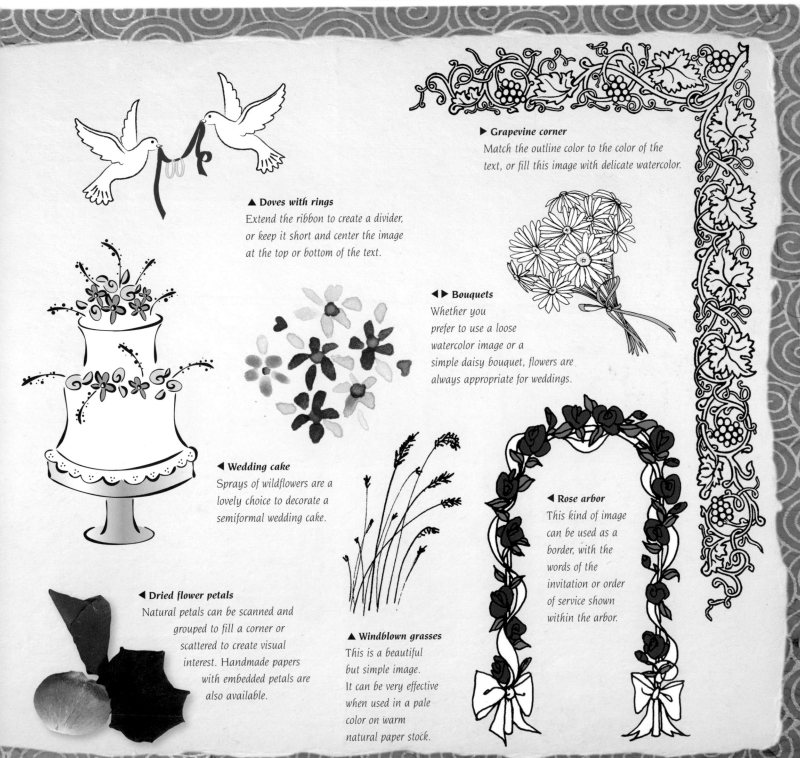

▶ Grapevine corner
Match the outline color to the color of the text, or fill this image with delicate watercolor.

▲ Doves with rings
Extend the ribbon to create a divider, or keep it short and center the image at the top or bottom of the text.

◀ ▶ Bouquets
Whether you prefer to use a loose watercolor image or a simple daisy bouquet, flowers are always appropriate for weddings.

◀ Wedding cake
Sprays of wildflowers are a lovely choice to decorate a semiformal wedding cake.

◀ Rose arbor
This kind of image can be used as a border, with the words of the invitation or order of service shown within the arbor.

◀ Dried flower petals
Natural petals can be scanned and grouped to fill a corner or scattered to create visual interest. Handmade papers with embedded petals are also available.

▲ Windblown grasses
This is a beautiful but simple image. It can be very effective when used in a pale color on warm natural paper stock.

Alphabet 5:
Gothic

The rich texture produced by these letters creates a certain and formal impression. Inspired by fourteenth-century manuscripts, this style is usually written in narrow columns for easier reading. It is a strong, disciplined alphabet that is sometimes overlooked, but it is a good choice for black-tie wedding invitations and stately ceremonies. Use Gothic capitals (pages 40–41) as the uppercase letters for this alphabet.

Tools

- 2-mm square-cut nib
- Straight penholder
- Permanent ink

40-degree dominant pen angle

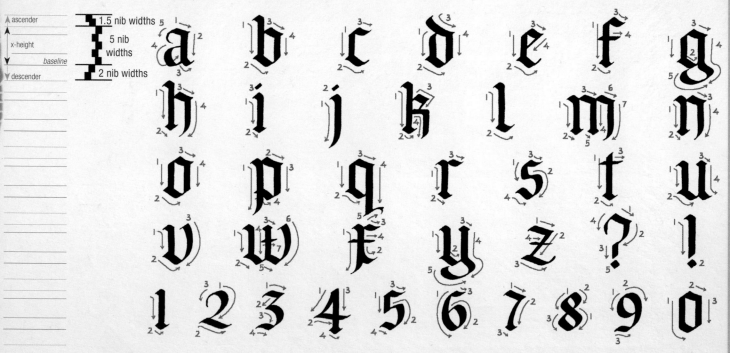

Note: Secondary guidelines are shown in pink to indicate the size of bowl tops and bottoms. Bowl tops are 1 nib width high; bowl bottoms are 2 nib widths high. Small letter feet are about half the height of the bottom bowls.

Distinguishing Features

Rhythmic vertical strokes are accented with slightly angular hooked serifs, diamond-shaped terminals, and serpentine bowl bottoms. Visual interest is created by the rounded bowl on a, v, and w, and a tapered right leg on h, k, m, and n. This alphabet is carefully constructed with uniform shapes. Ascenders and descenders are kept very short to minimize interlinear space and create a tight visual weave.

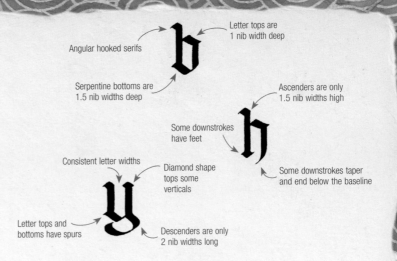

Letter tops are
1 nib width deep

Angular hooked serifs

Serpentine bottoms are
1.5 nib widths deep

Ascenders are only
1.5 nib widths high

Some downstrokes
have feet

Consistent letter widths

Diamond shape
tops some
verticals

Some downstrokes taper
and end below the baseline

Letter tops and
bottoms have spurs

Descenders are only
2 nib widths long

Letter Construction

1 Maintaining a 40-degree pen angle for all strokes, start by placing the nib just below the top of the x-height and pull a slightly convex stroke. Pause when the left edge of the nib is at about ½ x-height, then pull right and slightly upward for a short distance. Pause again and then make another slightly curved vertical, ending just above the baseline.

2 Overlapping the top of stroke 1, pull a short, slightly cupped horizontal to the right.

3 Position the nib about 1.5 nib widths above the baseline and just left of the upper bowl. Pull a slightly serpentine stroke, ending by overlapping the narrow end of stroke 1.

1 Maintaining a 40-degree pen angle for all strokes, begin a little below the x-height. Pull a small hairline, then make a short straight stroke, ending about 1 nib width above the baseline.

2 Beginning about 1.5 nib widths above the baseline, make a slightly serpentine stroke down to the baseline and end with a short upward hairline.

3 Overlap the top of stroke 1 with a short hairline and then pull right, moving 1 nib width downward.

4 Overlap stroke 3, allowing its right corner to overhang. Pull straight down to overlap the short hairline of stroke 2, and then make a short serpentine curve.

5 Position the nib just below the bottom point of stroke 2 and pull a wide curve around. End on a hairline, overlapping the tip of stroke 4.

Letter Spacing

The spaces between letters are equal to the counter space within the n.

Alphabet 6:

Gothic capitals

This carefully constructed uppercase alphabet echoes the shapes of the lowercase Gothic alphabet (pages 38–39). The decorative fine lines add formal detail, and the rounded shapes offer visual resting places within the dense texture created by the lowercase letters. These capitals are not intended for use on their own, but to accompany the lowercase letters as bold entry points to formal invitations and to punctuate grand announcements.

Tools

- 2-mm square-cut nib
- Stiff pointed nib (optional)
- Straight penholder
- Permanent ink

40-degree dominant pen angle; changes to pen angle are indicated next to the stroke

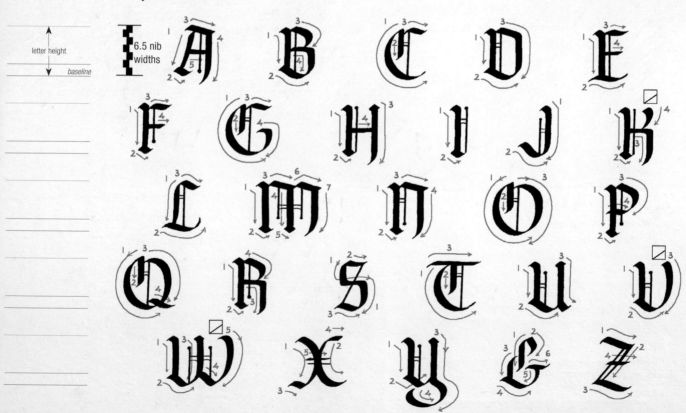

Note: Secondary guidelines are shown in pink to ensure the consistent height of bottom bowl strokes. The fine decorative lines are added after the main strokes and are not numbered.

Distinguishing Features

These letters have the same slightly angular hooked serifs, diamond-shaped feet, and serpentine letter bottoms found in the lowercase alphabet. Rounded letter shapes provide light within a body of compact text. The main strokes of the letters are made with a 2-mm nib; the decorative fine lines are drawn in later with a stiff pointed nib, but you could create them by pulling wet ink from the letter with the corner of the 2-mm nib instead.

Slanted letter tops
Vertical letters
Right downstroke tapers and ends below baseline
Angular hooked serifs
Diamond-shaped top
Left downstroke sits on a foot
Decorative fine lines
Consistent letter widths
Serpentine letter bottoms

Letter Spacing

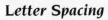

The space between capital and lowercase letters is about the same as the counter space within the lowercase n.

Letter Construction

1 Maintaining a 40-degree pen angle for all strokes, begin by positioning the 2-mm nib just below the top guideline and pull a large curve that just breaks the baseline before curling upward.

2 Overlap the thin top of stroke 1 and extend a straight line down below mid-height.

3 Position the nib so that it overlaps stroke 2, leaving a small triangular gap at the top, and make a subtle serpentine horizontal.

4 Pull a short horizontal before cornering softly downward, and end by overlapping the tip of stroke 1. Use a stiff pointed nib to add fine decorative lines.

1 Maintaining a 40-degree pen angle for all strokes, start by placing the 2-mm nib at the upper guideline and make a short diagonal stroke before falling straight downward, stopping about 1 nib width above the baseline.

2 Beginning about 1.5 nib widths above the baseline, make a slightly serpentine stroke down to the baseline and end with a short upward hairline.

3 Position the nib so that it overlaps stroke 1, leaving a small triangular gap at the top, and pull the slanted letter top before making a soft turn and continuing straight down; end with a thin line to overlap the tip of stroke 2.

4 Use a stiff pointed nib to add fine decorative lines.

Borders and Embellishments:
Gothic

This strong, dense lettering is complemented by a graphic image, motif, or border. Silhouettes, classic borders, and stylized images work well with Gothic lettering. If the graphic nature of this style is appealing but a softer look is preferred, try lowering the contrast by using more subdued colors.

▲ Wedding bells

Motifs like this can be reduced in size and used to create matching stationery items, such as R.S.V.P. cards and place cards.

▼ Borders

Filigree or geometric borders are strong enough to balance the bold texture of Gothic lettering.

▶ Dingbats

Graphic elements can be used in corners or as dividers. Reduced and repeated, they can make a background pattern for layering.

▲ Doves and heart
You can strengthen this traditional design by tracing it and applying a heavier weight outline.

▶ Metallic wedding bells
Stick metallic shapes to cards to complement drawn wedding bell motifs.

▲ Stained glass
This bold image could be centered and used full size, or reduced and used in a row of three or more repeated motifs.

◀ Tile motifs
Celtic and geometric motifs can be used to punctuate invitations and matching stationery.

▲ Horseshoes
These could be colored to simulate brass or pewter. This image could also be adapted for embossing.

◀ Lily
This image is large enough to use as an illustrative border, or it could be adapted and used as an embossed border.

▶ Bouquet
Choose a flower image that is not too delicate. Strong color can make the image look bolder.

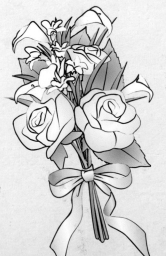

◀ Wedding cake
This cake is composed of clean lines and simple shapes. It could easily be adapted to the color theme of the wedding.

▼ Paper flowers
There are lots of embellishments available at craft stores that will add a third dimension to your cards and invitations.

Holidays

Celebrate holidays by sending handmade cards with greetings that reflect the season. The layout ideas opposite can be adapted for any occasion. Choose a significant word, a playful holiday character, or a symbolic image as the focal point, and add lettering or special effects such as embossing, layering, or cutouts to create designs that are uniquely yours.

Layers of torn-edged papers frame the Greetings lettering. The lower edge of the front of the card is torn slightly shorter than the back of the card to reveal the color inside.

An embossed heart with a debossed heart tucked in behind it supports a short Sweetheart message floating above.

Spiders frame the lettering, with some of them escaping to explore other parts of the card; some have even made their way into the text. Start with a large Phantom letter followed by Gothic text.

Dark red card stock with a triangular cutout window finely outlined in gold and topped with a gold stick-on star. Green Greetings lettering shows through the window from the inside.

A delicate hearts-and-kisses border around centered Sweetheart lettering with a rose motif below.

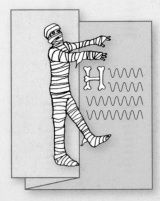

A duofold card with a mummy's arms and legs cut out so that they overlap the back section. A Phantom letter leads into a block

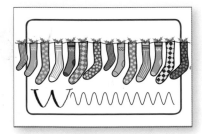

A row of stockings is framed by a loosely hand-drawn red border, with Greetings text within the border.

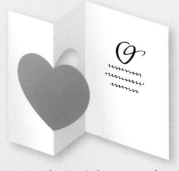

A duofold card with a simple heart cutout that moves forward when the card is opened. The lettering on the inside is topped with a stylized Sweetheart ampersand.

Hand-drawn bats fly out from the top of the card, with a single line of text mounted onto a separate piece of paper below. Use all Phantom letters for a short word, or use Phantom initials with Gothic letters for longer pieces of text.

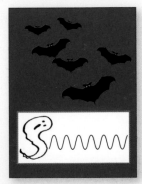

Alphabet 7:
Greetings

This monocase alphabet is an adaptation of a traditional letter style called Uncial. Generous counter spaces give the alphabet its cheerful appeal, while contrasting line weights help to maintain some formality. The alphabet is quite flexible and can be used for a wide variety of holiday greetings. Maintaining consistency in the heavier line weight may take some practice with a pointed nib.

Tools

- Flexible pointed nib
- Straight penholder
- Permanent ink

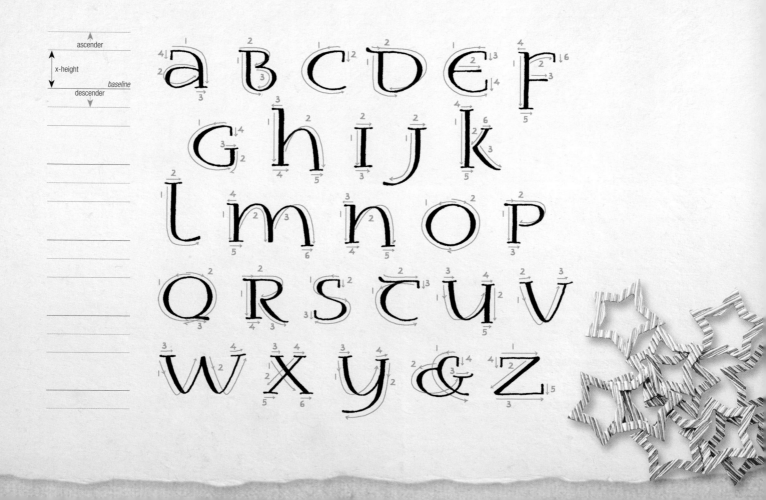

Distinguishing Features

Oval arches spring from the vertical at ½ x-height, and generous oval bowls carry their weight just above center height. The short ascenders and descenders are about half the x-height. The arches of H and N, and the second arch of M, drop slightly, and the leg reaches to the right, ending just below the baseline. The first arm of U and Y reaches slightly left, while the second arm drops slightly. The kick-legs on K and R end just below the baseline. A little weight is added to the tips of the fine serifs.

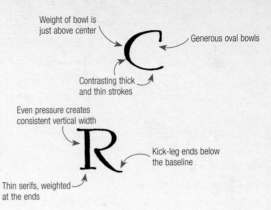

Weight of bowl is just above center

Generous oval bowls

Contrasting thick and thin strokes

Even pressure creates consistent vertical width

Kick-leg ends below the baseline

Thin serifs, weighted at the ends

Letter Spacing

Oval letters are packed closely together.

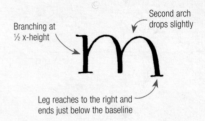

Branching at ½ x-height

Second arch drops slightly

Leg reaches to the right and ends just below the baseline

Letter Construction

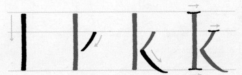

1 Put pressure on the nib and then begin the vertical stroke, maintaining pressure for about ¾ of the letter height. Gradually release pressure to taper the stroke and pull right to create a curved bottom.

2 Starting with minimal nib pressure, gradually increase pressure when turning the bowl and then release, ending just above mid-height.

3 Overlapping stroke 2, gradually increase pressure as you approach the widest part of the bowl. Then gradually release pressure and finish by overlapping stroke 1.

4 Add weight to the serif by putting a little ink at the beginning of stroke 2.

1 Add pressure to splay the nib, then maintain this pressure to make a vertical stroke.

2 Splay the nib slightly less than before to make a diagonal stroke. Release pressure to taper the stroke, ending just before touching the vertical and at about ½ x-height. Include a very modest outward curve.

3 Begin this stroke with about the same nib pressure as stroke 1. Gradually release pressure to taper the stroke, ending just below the baseline. Include a very modest inward curve.

4 Add thin serifs, and then go back and add weight to the serif ends.

Borders and Embellishments:
Greetings

There is an abundance of images available for this holiday. Greetings is a warm and cheerful alphabet, suitable for use with most images, but it may be overpowered by heavy or dark line quality. Although red and green are the traditional colors for the season, consider using crisp blues instead. The shimmer of metallic silver or gold will add a touch of magic to any holiday card.

▲ Angel
This angel could be flipped horizontally if needed, to suit the layout design.

▼ Borders
Christmas offers a wide range of motif ideas that could be used for borders: trees, candy canes, stockings, holly, and reindeer, to name just a few.

▶ Snowmen
These charming, hand-colored rubber stamps could be arranged in a square or used individually on gift tags.

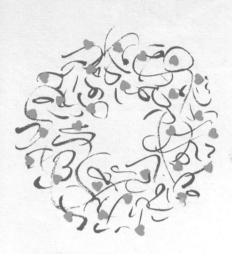

▲ Calligraphic wreath
Create unique wreath images from calligraphic brush or pen marks. Instead of decorating it with hearts, you could substitute brightly colored ornaments.

▲ Snowflakes
Detailed and unusual snowflakes can be cut from white or colored paper and scanned or adhered to cards. You can also buy ready-cut snowflakes from craft stores.

▲ Fairy light corners
Brighten up the corners of cards or create a whole border with a string of colored lights.

▲ Candy cane
Use a series of simple candy cane images and add interest by changing the color of just one of the bows.

▶ Santa
There are many rubber stamps and clip art images of this favorite old fellow to choose from.

▼ Die-cut stars
Stars are easy to draw, or use the many different star embellishments that are available from craft stores.

▼ Poinsettia corner
Add gold dots to the center of the poinsettia for extra sparkle.

▲ ▶ Christmas trees
Christmas trees can be full and formal or spindly and charming.

Alphabet 8:
Sweetheart

Tools

- Flexible pointed nib
- Straight penholder
- Permanent ink

Subtle heart-shaped bowls and curved lines are combined to create this warm but whimsical alphabet. It is sweet enough for Valentine's cards, and charming enough for casual shower or wedding invitations. Some letters interact playfully by tilting forward. Contrasting line weights combined with a delicate line quality add a touch of sophistication to the alphabet. Use Sweetheart capitals (pages 52–53) as the uppercase letters for this alphabet.

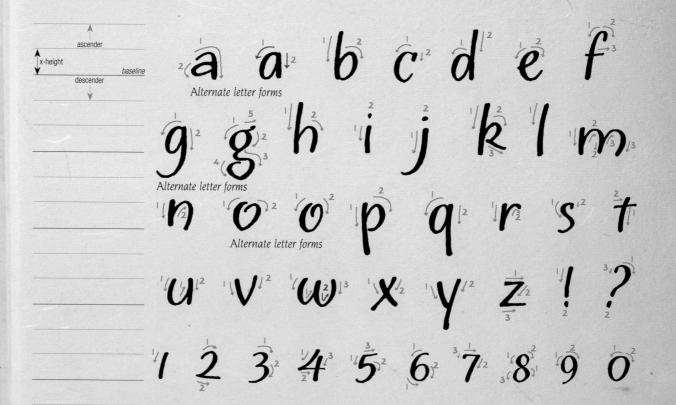

Alternate letter forms

Alternate letter forms

Alternate letter forms

Distinguishing Features

The flexible pointed nib allows you to create letters with thick and thin strokes, without concern for the pen angle. The tilted oval-shaped counter spaces suggest a heart shape, and all vertical and diagonal strokes have a subtle curve. Pressure must be added to the nib before beginning heavier strokes, so that the top of the strokes will be rounded. Likewise, pressure must be released before lifting the pen, in order to create rounded bottoms on those strokes.

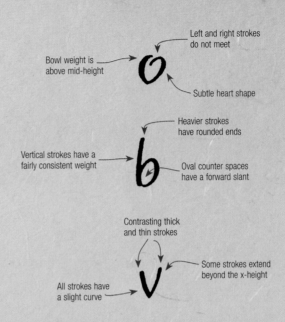

Bowl weight is above mid-height

Left and right strokes do not meet

Subtle heart shape

Heavier strokes have rounded ends

Vertical strokes have a fairly consistent weight

Oval counter spaces have a forward slant

Contrasting thick and thin strokes

Some strokes extend beyond the x-height

All strokes have a slight curve

Letter Spacing

iloevra

Letters sometimes tilt forward and some letters extend above the x-height.

Letter Construction

1 Put pressure on the nib and then make a slightly curved vertical stroke. Release the pressure and allow the tines to spring shut before lifting the nib.

2 Position the nib within stroke 1 at about ½ x-height and then flip over the top of the x-height guideline. Begin to add pressure to the nib as you turn to make the right side of the bowl, then release the pressure to end with a thin line.

3 Overlapping the end of stroke 2, pull a short, angled kick-leg, ending above the baseline.

1 Starting just above the x-height, apply pressure to the nib and then begin the curved stroke. Gradually release the pressure as you approach the baseline, bouncing back upward with a thin stroke.

2 Beginning slightly lower than stroke 1, put pressure on the nib and make another curved stroke. Gradually release the pressure as you approach the baseline, and then bounce back up.

3 Apply pressure and then begin the stroke, curving inward. Release the pressure at about ½ x-height, and overlap the thin part of stroke 2.

Alphabet 9:

Sweetheart capitals

Soft corners and relaxed verticals give these letters a look of sincerity and vulnerability. They can be used alone for captions on cards, or as capital letters to accompany lowercase Sweetheart (pages 50–51) on greetings or invitations. Bowls are larger at the top and taper inward toward the bottom, suggesting the heart shape found in the lowercase letters.

Tools

- Flexible pointed nib
- Straight penholder
- Permanent ink

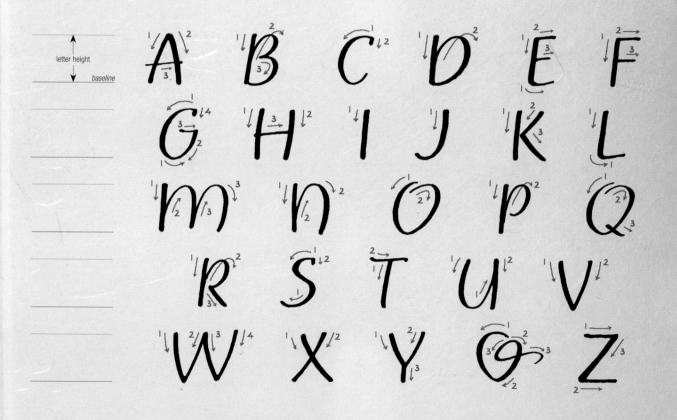

Distinguishing Features

These letters sway forward and backward, and all pen strokes have a slight curve to them. Stability is achieved with line weights and letter shapes that remain consistent. Thick lines are created by putting pressure on the nib. When making thick lines, apply pressure to the nib before beginning the stroke and release pressure before lifting the nib. Branching occurs at about half the letter height, and bowls suggest a heart shape.

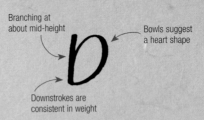

Branching at about mid-height

Bowls suggest a heart shape

Downstrokes are consistent in weight

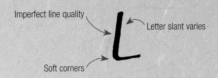

Imperfect line quality

Letter slant varies

Soft corners

Letter Spacing

Ro Li Va

These uppercase letters can be used alone or as capitals for the lowercase alphabet. Letters tilt forward, playfully interacting with each other.

Contrasting thick and thin strokes

Counter spaces are about equal width

Letter Construction

I P B L C E

1 *Put pressure on the nib to splay the tip before beginning, and then maintain pressure throughout the vertical stroke. Release pressure before lifting the nib.*

2 *Position the nib within stroke 1; do not add pressure. Retrace for a short distance and then branch out. Add pressure as you turn the bowl, and then release pressure to taper the stroke, ending a little above mid-height.*

3 *Position the nib over the end of stroke 2. Gradually add and then release pressure as you turn the bowl shape, and finish by overlapping the end of stroke 1.*

1 *Put pressure on the nib to splay the tip before beginning. Turn just before reaching the baseline, release the nib pressure, and pull slightly upward, ending just above the baseline.*

2 *Begin by overlapping the top of stroke 1 and pull a thin line with a slight upward tilt.*

3 *Position the nib within stroke 1 and just above mid-height. Make a short thin line with a slight upward tilt.*

Borders and Embellishments:
Sweetheart

Valentine images are usually seen in red and white, but cards, invitations, and party decorations can be given a boost by pinks, purples, golds, and greens. The simple heart shape can be stylized or filled with pattern, and a wide variety of traditional and contemporary images are available for this occasion.

▼ Cupid
Cupid is a traditional image for Valentine's Day cards or party invitations. You could color the hair, wings, ribbon, and bow metallic gold for added sparkle.

▼ Borders
Hearts are easy to draw and can be adapted and repeated in a variety of ways for borders, dividers, or as decoration for an envelope.

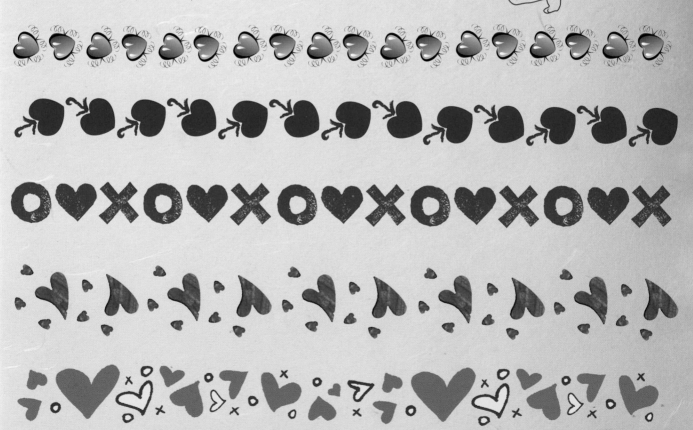

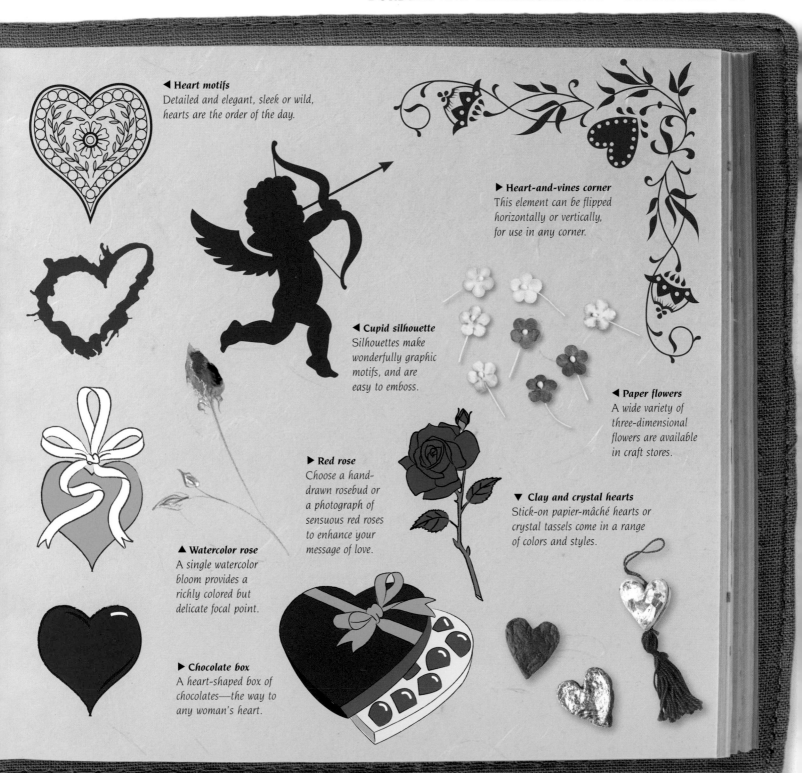

◄ Heart motifs
Detailed and elegant, sleek or wild, hearts are the order of the day.

► Heart-and-vines corner
This element can be flipped horizontally or vertically, for use in any corner.

◄ Cupid silhouette
Silhouettes make wonderfully graphic motifs, and are easy to emboss.

◄ Paper flowers
A wide variety of three-dimensional flowers are available in craft stores.

► Red rose
Choose a hand-drawn rosebud or a photograph of sensuous red roses to enhance your message of love.

▼ Clay and crystal hearts
Stick-on papier-mâché hearts or crystal tassels come in a range of colors and styles.

▲ Watercolor rose
A single watercolor bloom provides a richly colored but delicate focal point.

► Chocolate box
A heart-shaped box of chocolates—the way to any woman's heart.

Alphabet 10: Phantom

This alphabet presents a variety of playful ideas to choose from. Motif letters work well as decorative capitals for use with longer bodies of Gothic-style text or simple block capitals. An entire alphabet could be created from a single motif, or a mix of characters could be used for a word or short phrase. Limit the number of motifs when using other strong embellishments.

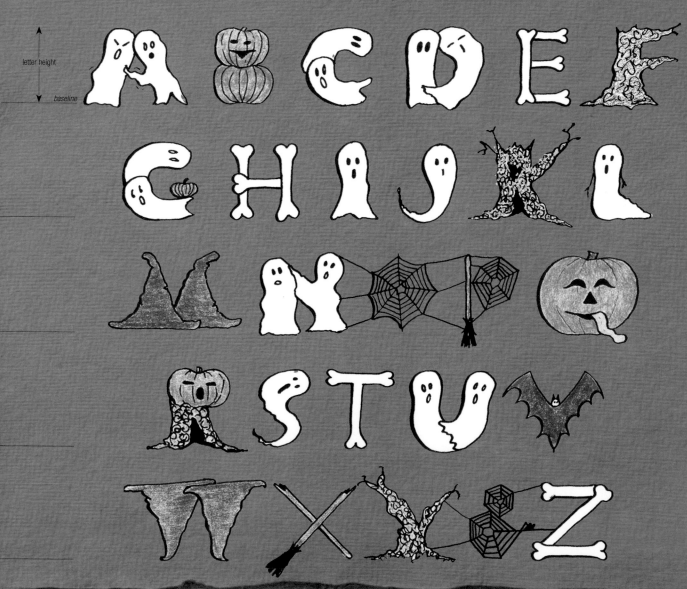

Tools

- H or HB *graphite pencil*
- *Eraser*
- *Flexible pointed nib*
- *Straight penholder*
- *Permanent ink*
- *Fine-line marker*
- *Colored pencils*

Distinguishing Features

Characters of consistent height are sketched in pencil before they are inked and colored. Pressure is added to the nib where a slightly heavier line weight is needed to suggest shadow in the outline. Shadowing should be fairly consistent throughout the alphabet. The color palette is limited to minimize visual confusion, and fine-line details are added to create texture, suggest action, or help identify images.

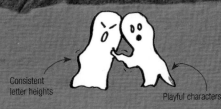

Consistent letter heights

Playful characters

Colored characters add visual interest

Slightly heavier line weight to indicate shadow

Fine-line details

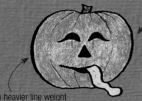

Limited color palette

Letter Spacing

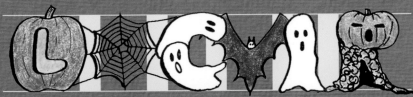

These letters can be packed quite closely together, with round characters touching and extensions overlapping.

Alternate Letter Forms

Use alternate forms, such as this A and U, to create balance within a word or caption. Word groupings will look better if there is an even sprinkling of color rather than a single orange pumpkin or one purple hat, so choose an alternate motif to add color where necessary.

Letter Construction

1 *Use an H or HB pencil to sketch the letter outline, then go over the outline with a flexible pointed nib. Add pressure to the nib to create heavier line weights that indicate shadows.*

2 *Add details using a fine-line marker.*

3 *Finish the letter motif using colored pencils.*

Borders and Embellishments:
Phantom

Halloween images can be a lot of fun and simple images, such as bats and witches' hats, can easily be repeated to make borders. Take advantage of black card stock for spooky-eyed cutouts, or spider webs drawn with gel pens. Try pop-up words and images to bring a smile to the young at heart. Clip art Web sites offer lots of choices when you are looking for unusual characters to help extend your party invitation or express a witty sentiment for this popular celebration.

◄ Mummy
This fun image can be flipped horizontally, used large as a sort of border, or cut out to overlap a colorful inside panel.

▼ Borders

Borders like these can be used vertically or horizontally, or around multiple edges. Black cats, spiders, and pumpkins are all easy to draw and highly effective.

◄ Halloween confetti
Confetti in the shapes of Halloween motifs is widely available, and can be glued in place or scanned and positioned as required.

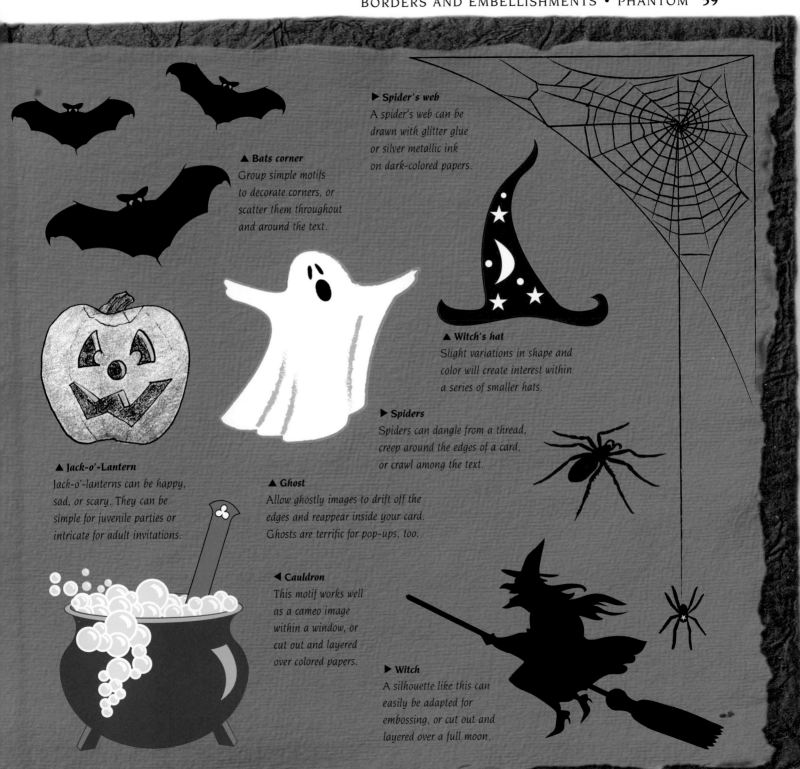

▶ Spider's web
A spider's web can be drawn with glitter glue or silver metallic ink on dark-colored papers.

▲ Bats corner
Group simple motifs to decorate corners, or scatter them throughout and around the text.

▲ Witch's hat
Slight variations in shape and color will create interest within a series of smaller hats.

▶ Spiders
Spiders can dangle from a thread, creep around the edges of a card, or crawl among the text.

▲ Jack-o'-Lantern
Jack-o'-lanterns can be happy, sad, or scary. They can be simple for juvenile parties or intricate for adult invitations.

▲ Ghost
Allow ghostly images to drift off the edges and reappear inside your card. Ghosts are terrific for pop-ups, too.

◀ Cauldron
This motif works well as a cameo image within a window, or cut out and layered over colored papers.

▶ Witch
A silhouette like this can easily be adapted for embossing, or cut out and layered over a full moon.

Birthdays

Consider the color combinations and image options used on the layout ideas opposite. Mix and match structures with embellishments and ideas that reflect the personality of the one whose birthday you would like to honor. Choose from simple images with monoline lettering, formal lettering with classic borders, or endless variations of paper cutting and decorating techniques for terrific birthday cards and invitations.

The front of a party invitation is cut shorter to reveal a candle border inside. Junior lettering is in multicolored crayon to match the candles.

A stack of cakes is the primary focal point, with Quipster lettering running up the right edge.

The large Jargon "50" is colored, while the Jargon lettering is not. The card front is cut around the "50" to reveal patterned paper on the inside, which features the color used for the numeral.

The front of this duofold card with Junior lettering is embellished with a paper-doll border. A chain of larger paper dolls pops up inside.

A piece of red paper is torn to mimic the shape of the motorcycle and applied to the front of the card. Vary the shape of the torn paper to suit the selected motif. Quipster lettering frames the image.

Hand-drawn stripes using a marker pen accent a block of Jargon lettering with a large, colored drop capital.

The brightly colored card stock is cut with "zigzag" scissors. A colorful clown motif on straight-edged paper is glued to the front, with Junior lettering below.

Gifts rain down onto a Quipster caption. Cut out the gifts from card stock and mount them using foam mounting tabs and spring pop-ups. Draw the "rain" lines on the base card.

Jargon lettering sits above a gift border. Select colors from the gifts to color random Jargon letters.

Alphabet 11: Junior

This is a carefree monocase alphabet, designed to be fun to write and easy to read. Use it to sing birthday wishes and invite friends to lighthearted celebrations. The size and shape of these letters can easily be varied and adapted to suit the text, and the guest of honor's favorite colors can be dropped into some of the counter spaces to make the text pop.

Tools
- 0.50-mm pigmented fine-line marker
- Colored pencils

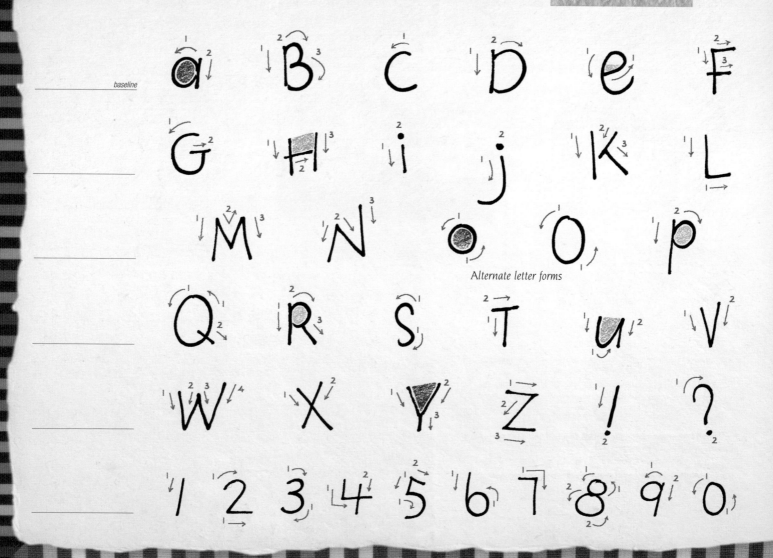

baseline

Alternate letter forms

Distinguishing Features

The letters skip up and down and tilt forward and back. Bright color can be added to some of the counter spaces to make the text even more cheerful. Letter shapes and sizes are inconsistent, and irregular spacing adds to the childlike quality of the alphabet. To make sure the text is readable, take care that you leave more room between words than between letters within words.

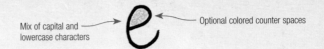

Mix of capital and lowercase characters

Optional colored counter spaces

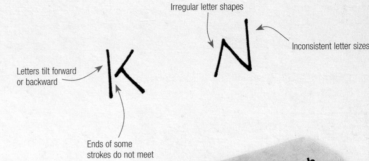

Irregular letter shapes

Inconsistent letter sizes

Letters tilt forward or backward

Ends of some strokes do not meet

Letter Spacing

Letters tilt and skip along the baseline. Spacing is irregular.

Design tip: **Mix & match**
This is a monocase alphabet, so mix and match capital and lowercase letters for a spontaneous look.

Letter Construction

1 *Make a downstroke with a slight backward tilt.*

2 *Draw another downstroke, but a little higher and at a slightly different angle to stroke 1.*

3 *Beginning a little to the left of stroke 1 and at about mid-height, make an angled crossbar that ends just before reaching stroke 2.*

4 *Use a colored pencil to fill in the upper counter space.*

1 *Make a downstroke with a slight backward tilt.*

2 *Overlapping stroke 1, draw a small round bowl that ends before you reach the downstroke.*

3 *Overlapping the end of stroke 2, make a larger round bowl that breaks through the baseline and ends before meeting the end of stroke 1.*

Borders and Embellishments:
Junior

Delight the young with cuddly characters, amusing images, or a hint about the gift to follow. Balloons, clowns, or friendly animals can be brought to life using bright colors, pop-ups, or cutouts. Every year is a special year for children, so large, animated numerals are always a hit. Match the colors in the alphabet's counter spaces with ones found in the images and decorative elements. If you use very bold images with heavier lines, a larger monoline tool could be used to do the lettering.

▼ Bright borders
Colorful borders can be made to complement almost any child's birthday theme. Stickers or punches can be used to make borders, too.

▶ Cute creatures
Lovable baby pets delight the young. Substitute kittens or puppies that look like the child's own pet.

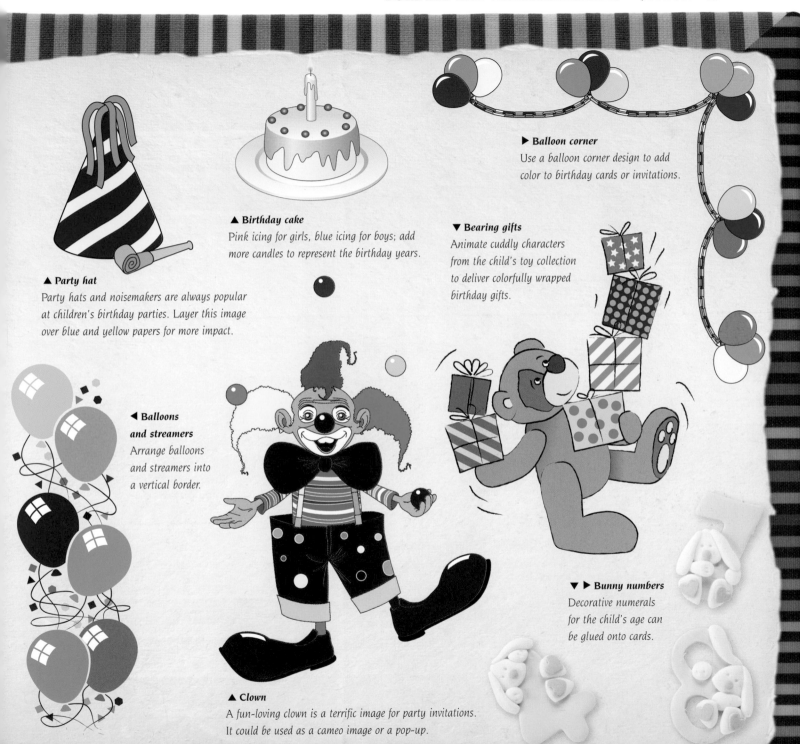

▲ Party hat
Party hats and noisemakers are always popular at children's birthday parties. Layer this image over blue and yellow papers for more impact.

▲ Birthday cake
Pink icing for girls, blue icing for boys; add more candles to represent the birthday years.

▶ Balloon corner
Use a balloon corner design to add color to birthday cards or invitations.

▼ Bearing gifts
Animate cuddly characters from the child's toy collection to deliver colorfully wrapped birthday gifts.

◀ Balloons and streamers
Arrange balloons and streamers into a vertical border.

▼ ▶ Bunny numbers
Decorative numerals for the child's age can be glued onto cards.

▲ Clown
A fun-loving clown is a terrific image for party invitations. It could be used as a cameo image or a pop-up.

Alphabet 12: Quipster

These stylized letter shapes are inspired by ancient cursive Roman alphabets. Some practice may be needed to get used to the quirky shapes, but once mastered they can be written quite quickly. This is a great monocase alphabet for punchy captions or clever quips, and it is strong enough for more masculine cards.

Tools
- Fine-point permanent marker

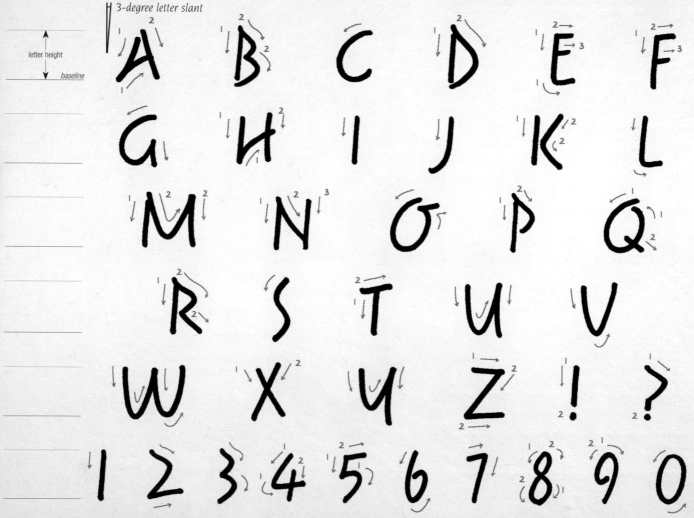

Note: Where there are no ductus numbers, the character is completed without pen lifts or pauses.

Distinguishing Features

Drawn with a slightly thicker monoline tool, these narrow letters have a minimal forward slant of 3 degrees. Stylized shapes with low-weighted bowls and a subtle upward lift on horizontal strokes reveal a sense of humor. The bowls of B, D, P, and R are almost triangular because of their steep sloping tops and abrupt curves. Letters often break through the guidelines, and there are occasional gaps where strokes do not quite meet, giving the alphabet a more casual look.

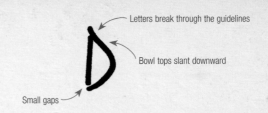

Letters break through the guidelines

Bowl tops slant downward

Small gaps

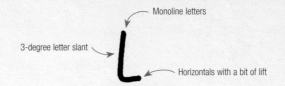

Monoline letters

3-degree letter slant

Horizontals with a bit of lift

Letter Spacing

Letter slant varies and some letters are dropped or raised slightly outside the guidelines.

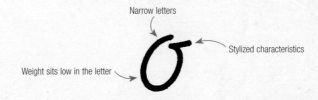

Narrow letters

Stylized characteristics

Weight sits low in the letter

Letter Construction

1 Begin at the top guideline and make a slightly slanted vertical down to the baseline.

2 Retrace stroke 1 briefly and then branch upward and to the right, ending at about ⅔ letter height.

3 Begin just above the top guideline and draw a slightly curved vertical, crossing over stroke 2 and ending a hair's width above the baseline.

1 Begin at the top guideline and draw a slightly slanted vertical, ending at the baseline.

2 Place the pen a little above stroke 1 and make a slightly curved short diagonal to the right, before making a quick turn at about ¾ letter height. This stroke stops just short of touching the vertical and slightly below mid-height.

3 Pause and change direction to draw a diagonal kick-leg that extends a little beyond the bowl.

Borders and Embellishments:
Quipster

Birthdays should be fun, and party-themed embellishments such as candles, cakes, and noisemakers can be used in a playful way to create lighthearted cards and invitations. Quipster is a confident but carefree-looking alphabet that can easily be scaled up or down to complement the embellishments. Humorists can take inspiration from recent events or characteristics and hobbies relevant to the birthday person. The embellishments featured here also combine well with Jargon (pages 70–73).

▲ Party popper
Cut around the image and adhere with mounting tape, or use as a pop-up for added impact.

▼ Themed borders
Traditional birthday motifs can be repeated to create borders around central text on invitations or cards.

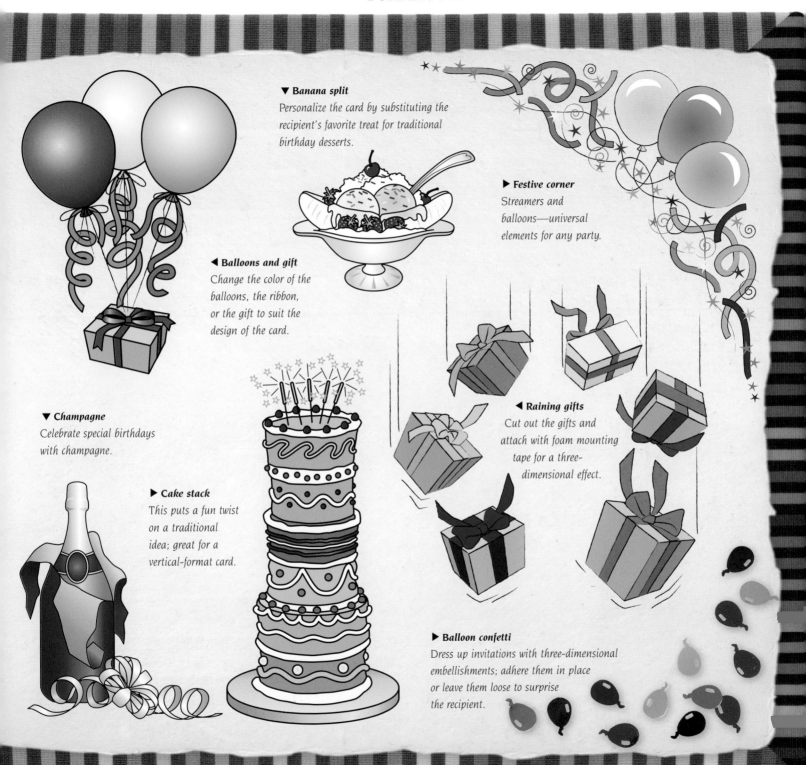

▼ Banana split
Personalize the card by substituting the recipient's favorite treat for traditional birthday desserts.

◄ Balloons and gift
Change the color of the balloons, the ribbon, or the gift to suit the design of the card.

► Festive corner
Streamers and balloons—universal elements for any party.

▼ Champagne
Celebrate special birthdays with champagne.

► Cake stack
This puts a fun twist on a traditional idea; great for a vertical-format card.

◄ Raining gifts
Cut out the gifts and attach with foam mounting tape for a three-dimensional effect.

► Balloon confetti
Dress up invitations with three-dimensional embellishments; adhere them in place or leave them loose to surprise the recipient.

Alphabet 13:
Jargon

Double-stroked verticals provide visual interest within these monoline letters and give them an open, updated look. Although hand-drawn line quality adds life to the text, some care is needed to draw consistent letters. This versatile alphabet can be written fairly quickly after some practice. Use Jargon capitals (pages 72–73) as the uppercase letters for this alphabet.

Tools
- 0.45-mm pigmented fine-line marker

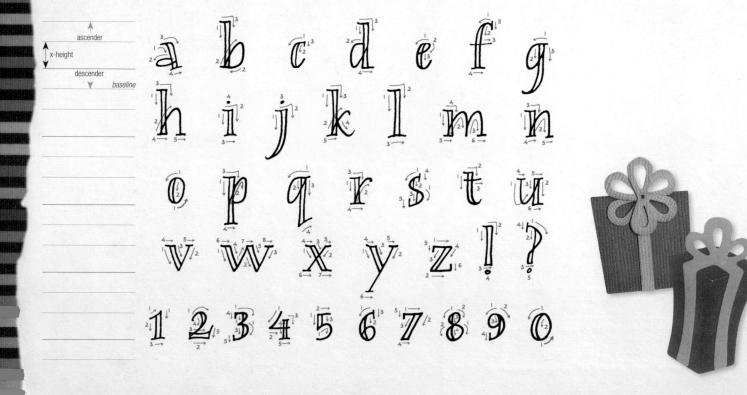

Distinguishing Features

Low-branching monoline strokes extend through the double-stroked verticals to make oval arches and angular bowls. Simple serifs connect the double-stroked verticals at top and bottom, but only extend in one direction. However, at the bottom of single strokes, serifs are centered to provide stability. These upright letters have ascenders and descenders that are a little shorter than the x-height.

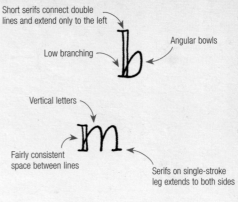

Short serifs connect double lines and extend only to the left

Angular bowls

Low branching

Vertical letters

Fairly consistent space between lines

Serifs on single-stroke leg extends to both sides

Letter Spacing

The spaces between letters are about the same as the counter space within the n. Serifs may join.

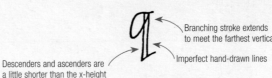

Branching stroke extends to meet the farthest vertical

Imperfect hand-drawn lines

Descenders and ascenders are a little shorter than the x-height

Letter Construction

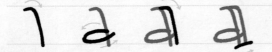

1 *Beginning just below the x-height guideline, make a short angled mark and then turn and draw a slightly slanted stroke down to just below the baseline.*

2 *Place the pen at about ⅓ x-height so that the tip overlaps stroke 1 and draw an oval bowl extending a little to the left of the top of stroke 1. End the stroke a little lower and to the right of where it began.*

3 *Overlapping stroke 1, pull right and then turn to make a line parallel to stroke 1 that ends on the baseline.*

4 *Add a short angled serif to join the bottom of strokes 1 and 3.*

Note: *Both construction examples have been enlarged for clarity.*

1 *Make a vertical line from the top of the x-height down to the baseline.*

2 *Briefly retrace the vertical and then branch out and up to the top of the x-height. Turn and drop straight down to the baseline.*

3 *Begin a little left of stroke 1, on the guideline. Draw a serif that extends about equal distance either side of stroke 1 and then drop straight down to the baseline.*

4 *At the baseline, begin a little left of stroke 1 and make a serif that connects strokes 1 and 3. Add a short serif to the bottom of stroke 2 that extends about the same distance either side of the downstroke.*

Alphabet 14:
Jargon capitals

Spontaneous-looking letters require the confidence of a practiced hand to make consistent shapes with quick hand movements. Make them large and dress them with color, dots, and flourishes to provide a focal point, or tone them down and omit the color when using them as capitals within a body of text. These oversized capitals are intended for use with lowercase Jargon (pages 70–71) or as accent letters.

Tools

- 0.45-mm pigmented fine-line marker
- Colored fine-line markers

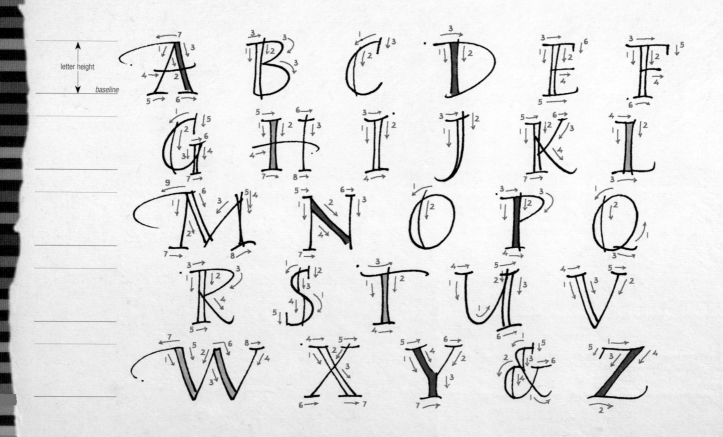

Distinguishing Features

Double-stroked verticals narrow slightly at about mid-height and can be filled with color to provide a bright accent. Use watercolors or bold marker color to achieve slightly different effects. Flourished horizontals and intermittent dots attract attention and add interest. Some strokes extend beyond the letter shape, while others stop short. Irregular serifs finish the ends of the double-line strokes and provide stability for contrasting single-line strokes.

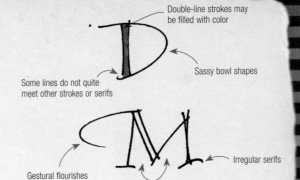

Double-line strokes may be filled with color

Some lines do not quite meet other strokes or serifs

Sassy bowl shapes

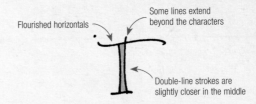

Gestural flourishes can be added

Contrasting single-line and double-line strokes

Irregular serifs

Letter Spacing

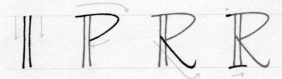

Uppercase letters drop below the baseline and may tilt forward or back.

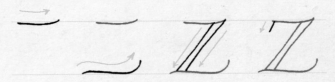

Flourished horizontals

Some lines extend beyond the characters

Double-line strokes are slightly closer in the middle

Letter Construction

1 Make two parallel vertical strokes, each bowing slightly inward at about mid-height.

2 Beginning a little left of the double vertical, draw an angular bowl that meets the right vertical at about mid-height.

3 Place the pen at the left vertical, slightly above mid-height, and pull a diagonal kick-leg that ends with an upward flick.

4 Add a little weight to the beginning of stroke 2. At the baseline, add a serif that extends to both sides of the double vertical.

1 Draw a concave horizontal at the top guideline.

2 Beginning a little to the left of stroke 1, draw a serpentine line at the baseline that curls upward and ends slightly to the right of stroke 1.

3 Join the end of stroke 1 and the beginning of stroke 2 with a pair of parallel diagonal strokes, each bowing slightly inward at the center.

4 Add a vertical serif to the beginning of stroke 1.

Borders and Embellishments:
Jargon

Jargon can be written with a larger-tipped marker to accompany bold images or the recommended fine-line marker to go with softer images. Choose a color from the embellishments and add it to capital letters to help unify the design. Classic cars and sporting motifs are popular choices for men, while softer elements such as flowers and butterflies may be good choices for the women in your social circle. The masculine embellishments featured here also combine well with Quipster (pages 66–67).

▲ Sailing boat

Choose a motif to represent the recipient's favorite sport, pastime, or hobby.

▼ Borders

Create simple borders by repeating hand-drawn images, use ruled or loose lines of varying widths and color, or select from a wide range of clip art.

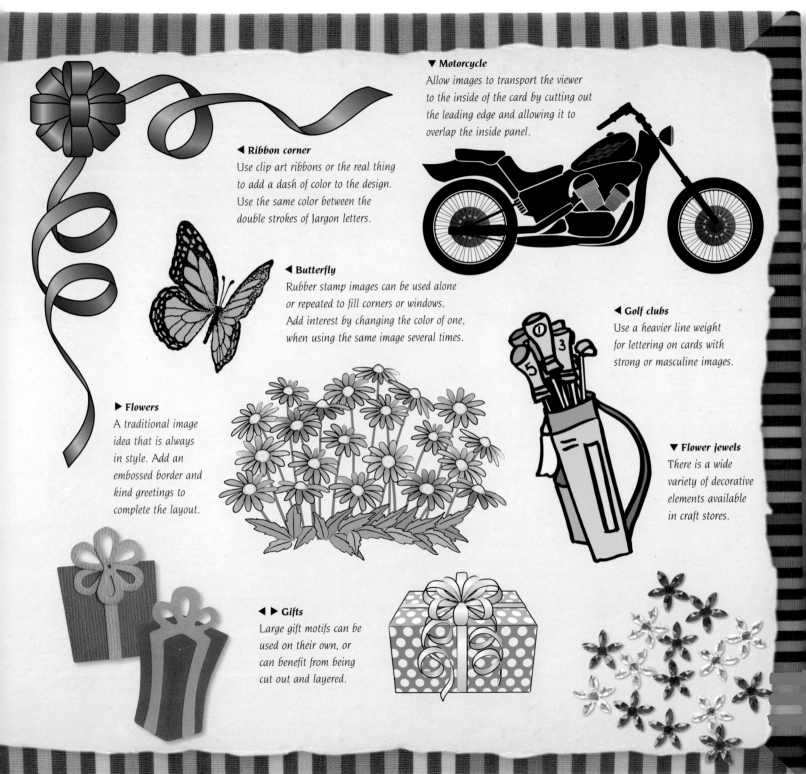

▼ Motorcycle

Allow images to transport the viewer to the inside of the card by cutting out the leading edge and allowing it to overlap the inside panel.

◄ Ribbon corner

Use clip art ribbons or the real thing to add a dash of color to the design. Use the same color between the double strokes of Jargon letters.

◄ Butterfly

Rubber stamp images can be used alone or repeated to fill corners or windows. Add interest by changing the color of one, when using the same image several times.

◄ Golf clubs

Use a heavier line weight for lettering on cards with strong or masculine images.

► Flowers

A traditional image idea that is always in style. Add an embossed border and kind greetings to complete the layout.

▼ Flower jewels

There is a wide variety of decorative elements available in craft stores.

◄ ► Gifts

Large gift motifs can be used on their own, or can benefit from being cut out and layered.

Milestones

Feature the wisdom of a hand-lettered quote
to offer support and encouragement, or use a
special photograph to punctuate a landmark
announcement. A few layout examples are offered
here to help stimulate ideas and experimentation.
Vary techniques and also consider alphabets from
other sections of this book to create keepsakes of
the important dates and achievements in the lives
of those you care about.

A translucent overlay has the baby's name in large Baby Steps lettering along the bottom. Beneath the overlay is card stock, with a baby's footprint framed with a fine-line border. To the right are written the birth details.

Write the numeral of the anniversary in Timeless numbers within a curlicue frame on a torn-edged piece of complementary colored paper. Layer this onto the front of the main card.

The front of the card is cut around the bow of the boat and overlaps the larger back portion. Italic lettering sends wishes for a bon voyage.

A birth announcement postcard with building blocks in soft pastel colors with the baby's initials printed on them. Baby Steps lettering spells out the baby's name above, and the birth date below. The lower edge of the card is colored in the least dominant color from the blocks.

An anniversary party invitation with an embossed border around a heart cut from patterned paper (or use a rubber stamp heart). The front of the card is cut so that it reveals Timeless lettering on the inside of the card, which is a pale version of the color used for the heart.

Send congratulations for a graduation with five small images mounted on layered pieces of paper with a short phrase written in Italic below. Choose images to represent the stages of the recipient's life—for example, a baby carriage, child's toy, musical note, sports ball, and graduation hat. Use outline images for a subtler effect.

A baby shower invite with Baby Steps lettering staggered around both sides of a pop-up motif. Connect the motif to the main part of the card with the hands and feet. Try using rich blue text for a boy or pink for a girl.

A heart-and-vine border frames lines of Timeless lettering. Start the text with a large capital; you could decorate it with a smaller tendril of vines and hearts.

Brightly colored diamond-shaped bullets introduce lines of Italic lettering with the characteristics of a good employee to wish someone well in a new job.

Alphabet 15: Baby Steps

This is a modern calligraphic alphabet with many of the warm, open characteristics of Uncial-style lettering, with a hint of formal book-hand tradition. It is appropriate for shower invitations, baby announcements, or cards to welcome new life. The alphabet can easily be scaled up or down by using different-sized pen nibs, and spacing should be as generous and consistent as the counter spaces within the letters. Use Baby Steps capitals (pages 80–81) as the uppercase letters for this alphabet.

Tools

- 2-mm square-cut nib
- Straight penholder
- Gouache

25-degree dominant pen angle; changes to pen angle are indicated next to the stroke

3-degree letter slant

ascender
x-height
baseline
descender

3 nib widths
5 nib widths
3 nib widths

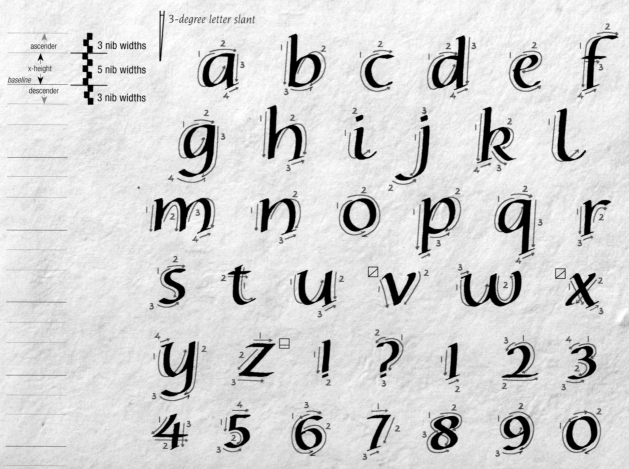

Distinguishing Features

Short ascenders begin with a modest hook serif, while descenders are finished with simple hairline serifs. A dominant pen angle of 25 degrees and low branching results in teardrop-shaped bowls. Carefully made letters have a subtle 3-degree forward slant, with an x-height of 5 nib widths, while ascenders and descenders are only 3 nib widths long. Rounded letter shapes make this alphabet open and easy to read, yet a formal appeal remains because of the graceful thick and thin strokes created by the broad-edged tool.

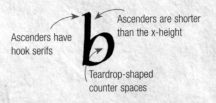

Ascenders have hook serifs

Ascenders are shorter than the x-height

Teardrop-shaped counter spaces

Contrasting thick and thin line widths

Branching at ½ x-height

Hairline serifs

Letter Spacing

iloevra

The spaces between the letters are the same width as the counter space in the n.

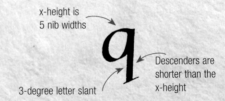

x-height is 5 nib widths

3-degree letter slant

Descenders are shorter than the x-height

Letter Construction

l h b v u u

1 *Using a 25-degree pen angle for all strokes, start by making a modest hook serif and then continue the vertical stroke at a slight 3-degree slant.*

2 *Begin stroke 2 by retracing the end of stroke 1, then branch to the right at about ½ x-height. End the stroke with a thin line, slightly above the baseline.*

3 *Make stroke 3 so that it overlaps the ends of the previous two strokes.*

1 *Using a 25-degree pen angle for all strokes, begin with a hairline serif and then continue around and up almost to the top of the x-height.*

2 *Starting at the end of stroke 1, make a vertical stroke that overlaps stroke 1 for about ¾ of the x-height. It should curve slightly outward.*

3 *Add a hairline serif at the bottom of stroke 2.*

Alphabet 16:
Baby Steps capitals

This alphabet was designed to complement lowercase Baby Steps (pages 78–79), but it can also be used on its own for short phrases or accent words. Two examples of flourished letters are included below. A light hand and practice are necessary to perform the pen manipulation required to realize these consistently. Large flourishes of this nature should only be used as a decorative element at the beginning of a line or text block.

Tools

- 2-mm square-cut nib
- Straight penholder
- Gouache

25-degree dominant pen angle; changes to pen angle are indicated next to the stroke

3-degree letter slant

letter height / baseline

8 nib widths

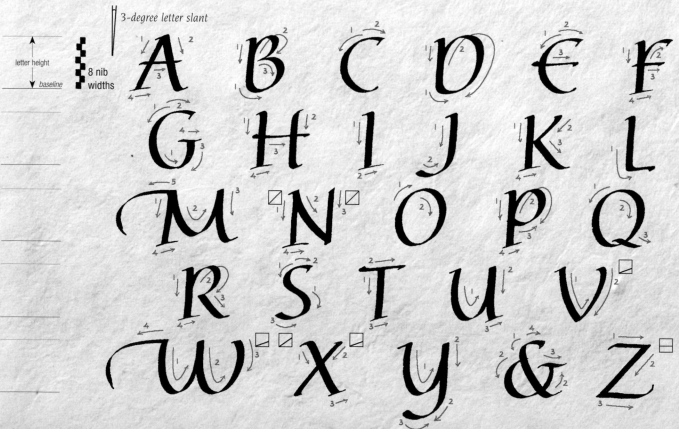

Note: Flourishes should only be added to letters at the beginning of a line or text block.

Distinguishing Features

These letters have a slight forward slant of 3 degrees and are made with a dominant pen angle of 25 degrees. The contrasting thick and thin strokes are created by using a broad-edged calligraphic pen. Oval counter spaces are transformed into a sweet teardrop shape because of mid-height branching on B, D, P, and R. Entry strokes are softened with modest hook serifs, and open letters such as C, E, and G are finished with fine tooth serifs that are pulled from wet ink with the corner of the nib.

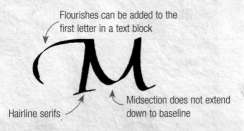

Contrasting thick and thin line widths

Hairline tooth serifs at top of open letters

3-degree letter slant

Ascenders have hook serifs

Branching at mid-height

Teardrop-shaped counter spaces

Flourishes can be added to the first letter in a text block

Hairline serifs

Midsection does not extend down to baseline

Letter Spacing

Ro Li Va

Letters sit on the baseline and serifs break through it.

Letter Construction

1 *Using a 25-degree pen angle, pull a horizontal stroke at the top of the x-height.*

2 *Flatten the pen angle to 0 degrees (horizontal) and make a diagonal stroke down and to the left, ending just beyond stroke 1.*

3 *Using a 25-degree pen angle again, pull a horizontal stroke along the baseline. At the end of the stroke, rotate the pen handle counterclockwise as you pull upward.*

1 *Using a 25-degree pen angle for all strokes, begin with a slightly curved stroke down to the baseline and bounce upward almost to the upper guideline.*

2 *Beginning at the top guideline and overlapping the end of stroke 1, make a slightly curved stroke down to the baseline and then bounce up, almost to the top guideline.*

3 *Complete the main part of the letter, starting at the top guideline and making a slightly curved stroke that overlaps the second half of stroke 2. To add the flourish, place the nib at the top of stroke 1 and pull a quick, light-handed stroke to the left. To make the tail of the flourish, rotate the pen handle counterclockwise as you pull downward.*

Borders and Embellishments:
Baby Steps

From baby shower to birth announcement, there are so many big events in the early life of a child. Draw a simple baby carriage, tiny footprints, or sweet baby toys to adorn the cards and invitations that mark the first steps of a baby's life. Use soft color with more whimsical images and more intense color with stronger images.

▲ Diaper baby

A fun image like this works well framed by layered paper or in a cutout window.

▼ Borders

Sweet borders can be created with a variety of simple baby motifs. Substitute real ribbon or lace to make a three-dimensional border.

▼ Toy motifs

A variety of toy clip art and rubber stamp images are available. Animal toys are always appropriate choices.

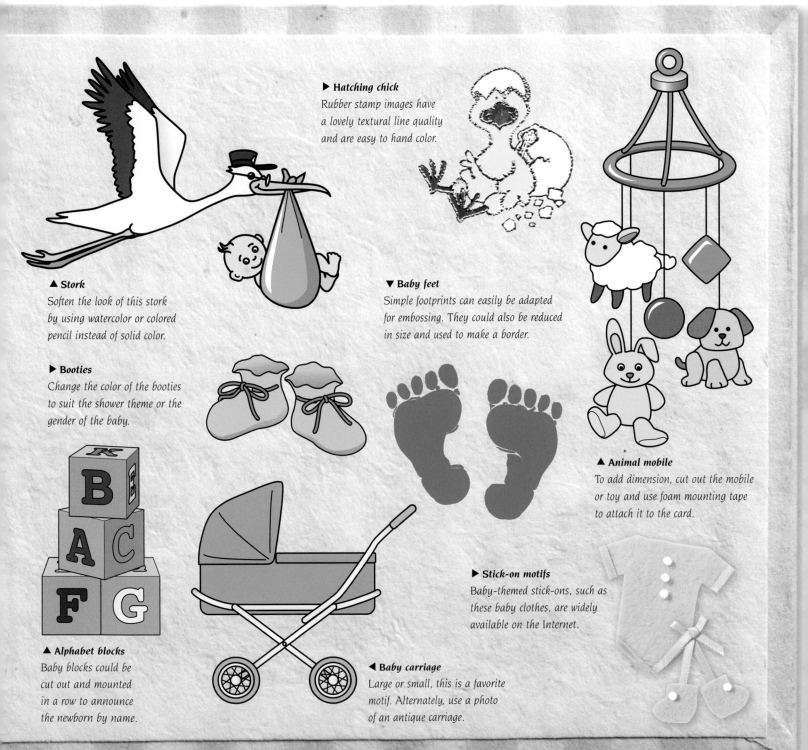

▶ Hatching chick

Rubber stamp images have a lovely textural line quality and are easy to hand color.

▲ Stork

Soften the look of this stork by using watercolor or colored pencil instead of solid color.

▶ Booties

Change the color of the booties to suit the shower theme or the gender of the baby.

▼ Baby feet

Simple footprints can easily be adapted for embossing. They could also be reduced in size and used to make a border.

▲ Animal mobile

To add dimension, cut out the mobile or toy and use foam mounting tape to attach it to the card.

▲ Alphabet blocks

Baby blocks could be cut out and mounted in a row to announce the newborn by name.

◀ Baby carriage

Large or small, this is a favorite motif. Alternately, use a photo of an antique carriage.

▶ Stick-on motifs

Baby-themed stick-ons, such as these baby clothes, are widely available on the Internet.

Alphabet 17:
Timeless

This semi-cursive hand has warmth and personality. It is a wonderful choice for use on congratulatory cards, or invitations to celebrate life's landmarks with family and friends. A variety of letter options and variations enable the artist to create a lively and genuine script that reflects the rhythm and joy of life. Use Timeless capitals (pages 86–87) as the uppercase letters for this alphabet.

Tools
- Flexible pointed nib
- Straight penholder
- Permanent ink

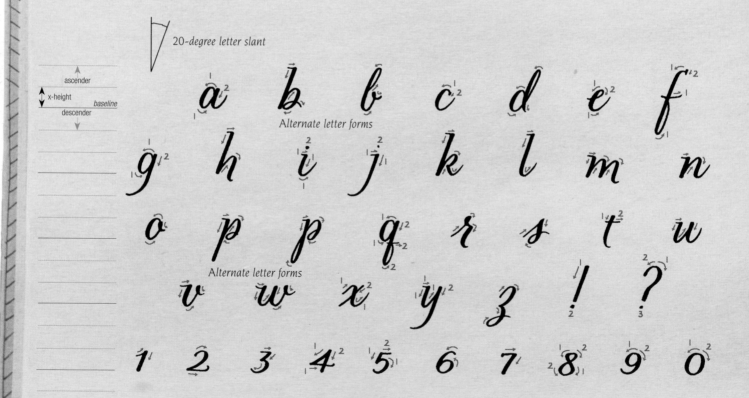

20-degree letter slant

ascender
x-height — baseline
descender

Alternate letter forms

Alternate letter forms

Note: Where there are no ductus numbers, the character is completed without pen lifts or pauses.

Distinguishing Features

Letters have short horizontal serifs, ascenders equal to the x-height, and slightly longer descenders. Optional looped or straight ascenders and descenders are offered, as well as the flexibility to choose which letters will have exit strokes that drop below the baseline. Text will be more pleasing when most of the letters join and an exit stroke drops the chain only once in every one or two words. The corresponding arch on h, m, or n should drop when the exit stroke drops, to avoid unusually long strokes. The exemplar shows h and m dropping and n remaining within the guidelines, but they can be varied.

Contrasting thick and thin strokes

Oval bowls

Most letters join to the next letter

Descending arches

Some exit strokes drop below the baseline

Counter spaces are about equal

Letter Spacing

Most letters join, and some drop below the baseline. The spaces between letters are about the same as the counter space within the n.

Short horizontal serifs

20-degree letter slant

Optional straight or looped descenders

Letter Construction

1 *Begin a little below the guideline and add pressure to the nib as you move up and over the top of the bowl. Release nib pressure just before the bottom turn and continue with a thin line until the oval is almost closed.*

2 *Put pressure on the nib to splay the tip and then make the downstroke; release the pressure just before the bottom and curl back up toward the baseline.*

3 *Continuing with the thin stroke, cross over the downstroke and pull right to create a crossbar just below the baseline.*

1 *Move the pen tip to the right, making a short, fine serif.*

2 *Add pressure and pull the downstroke on a 20-degree slant; maintain even pressure for the whole stroke. Without lifting the pen, release the pressure and allow the tines to close.*

3 *Move the pen upward, retracing the downstroke, and branch out to about ½ x-height. Add pressure as you turn the top of the bowl; drop downward parallel to the downstroke. Begin to release the nib pressure as you approach the baseline and turn the bottom of the bowl; turn quickly to make a small exit loop to the right.*

Alphabet 18:
Timeless capitals

This alphabet has the understated elegance and beauty that seems so suitable for the celebration of life's personal touchstone moments. Lovely uppercase letters have clean lines, graceful curves, and just enough tapered and extended downstrokes to complement the cadence of the lowercase Timeless alphabet (pages 84–85) that it is designed to accompany.

Tools

- Flexible pointed nib
- Straight penholder
- Permanent ink

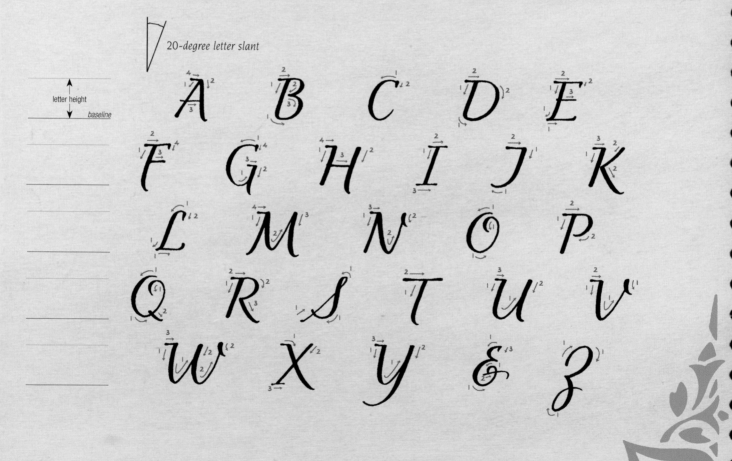

20-degree letter slant

letter height

baseline

Distinguishing Features

Modern oval-shaped bowls carry their weight above center. C, E, F, G, and L have small tooth serifs, while other letters have thin horizontal serifs with an extra touch of ink at the tip to give them more significance. This style is written at a 20-degree letter slant, with graceful curves and contrasting thick and thin strokes. Some vertical strokes taper and extend beyond the baseline.

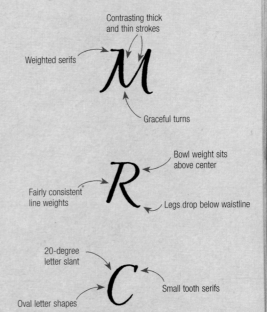

Contrasting thick and thin strokes

Weighted serifs

Graceful turns

Bowl weight sits above center

Fairly consistent line weights

Legs drop below waistline

20-degree letter slant

Oval letter shapes

Small tooth serifs

Letter Spacing

Ro Li Va

The space between capital and lowercase letters is about the same as the counter space within the lowercase n.

Letter Construction

I ✓ K K K

1 Put pressure on the nib to splay the tip and then make the downstroke at a 20-degree slant. Release the pressure and allow the tines to close before lifting the pen.

2 Begin this stroke a little higher than stroke 1. Apply pressure on the nib and then pull the stroke, tapering the weight slightly as you approach mid-height. Pause just as the stroke kisses the downstroke.

3 Applying the same pressure used on stroke 1, pull the kick-leg; end with a soft flick below the baseline.

4 Add a horizontal serif to the beginning of stroke 1.

5 Add a little weight to the beginning of the serif.

L P B B

1 Put pressure on the nib to splay the tip and then make the downstroke at a 20-degree slant. Just before reaching the baseline, release pressure and turn to the right to create a soft corner.

2 Begin a little left of stroke 1 to make a short serif, then continue with a very subtle upward curve before increasing pressure and turning the first bowl. Reduce pressure slightly and complete the first bowl a little above mid-height.

3 Overlapping the end of stroke 2, gradually add pressure to increase the line weight as you turn the second bowl. Release pressure gradually as you approach the baseline, and end by overlapping the end of stroke 1.

4 Add a little weight to the beginning of the stroke 2 serif.

Borders and Embellishments:
Timeless

Flowers, wedding images, and playful hearts are all appropriate embellishments for cards or invitations to celebrate an anniversary. Mark significant years such as 10th, 25th, and 50th with bold numbers. Muted colors can be very tasteful and black and white can be quite formal looking. Color can also be chosen to reflect the traditional gifts for each anniversary—for instance, 25th is silver and 40th is ruby.

▼ Ribbon and bow border
Tie the ribbon into heart shapes for an anniversary theme.

▶ Anniversary cake
Change the numbers on the cake to match the anniversary celebration.

◀ ▼ Tulip border and divider
Floral images make lovely frames for lettering and motifs for anniversary celebrations.

▲ Heart-and-vine border
Delicate borders work well with this alphabet style. Continue the tendrils around corners and motifs.

▲ Curlicue frame
Place the numeral of the anniversary inside a hand-drawn frame.

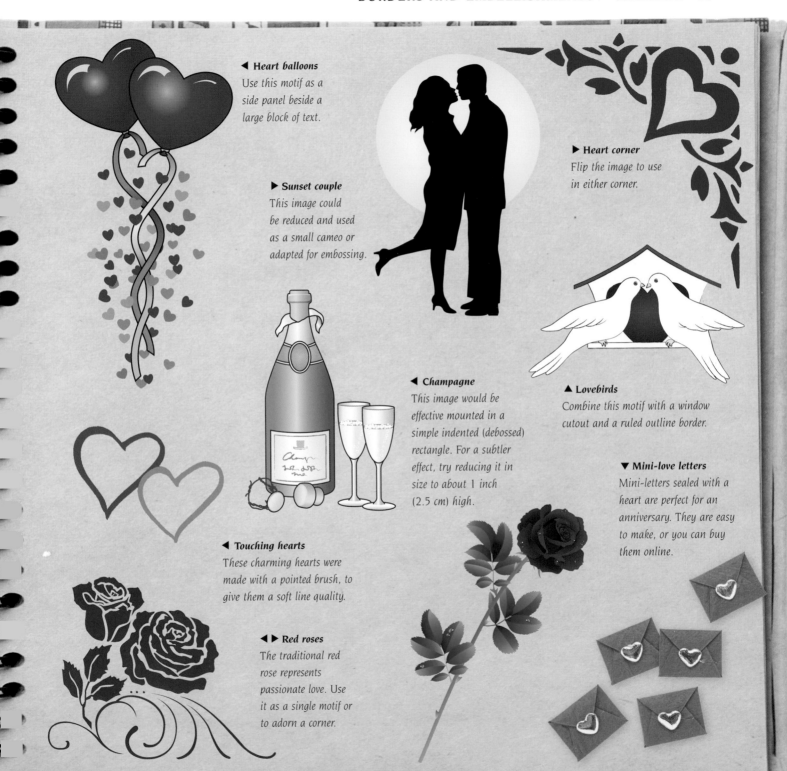

◄ Heart balloons
Use this motif as a side panel beside a large block of text.

► Sunset couple
This image could be reduced and used as a small cameo or adapted for embossing.

► Heart corner
Flip the image to use in either corner.

◄ Champagne
This image would be effective mounted in a simple indented (debossed) rectangle. For a subtler effect, try reducing it in size to about 1 inch (2.5 cm) high.

▲ Lovebirds
Combine this motif with a window cutout and a ruled outline border.

▼ Mini-love letters
Mini-letters sealed with a heart are perfect for an anniversary. They are easy to make, or you can buy them online.

◄ Touching hearts
These charming hearts were made with a pointed brush, to give them a soft line quality.

◄ ► Red roses
The traditional red rose represents passionate love. Use it as a single motif or to adorn a corner.

Alphabet 19: Italic

This is a very appealing, classic calligraphic style, appropriate for cards, announcements, or invitations to mark any special occasion. The exemplar illustrates exit strokes that require some pen manipulation and will make letters look as though they are linked together. However, this alphabet can also be done very successfully without manipulation. Consistent rhythm and spacing will make any text written in this style sing. Use Italic capitals (pages 92–93) as the uppercase letters for this alphabet.

Tools

- 2-mm square-cut nib
- Straight penholder
- Gouache

10-degree letter slant

30-degree dominant pen angle; changes to pen angle are indicated next to the stroke

ascender

x-height

baseline

descender

4 nib widths

5 nib widths

4 nib widths

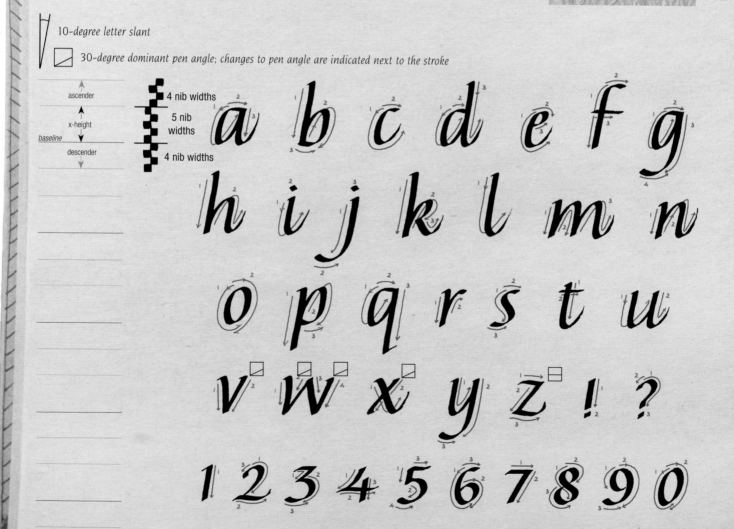

Distinguishing Features

This low-branching alphabet is written with a dominant pen angle of 30 degrees, but all diagonal strokes require a pen-angle change. Letters have a constant forward slant of 10 degrees, with oval shapes and consistent widths. The x-height is 5 nib widths; the ascenders and decenders are 4 nib widths long. Downstrokes begin with a modest hairline entry stroke, while exit strokes require some counterclockwise pen manipulation. Contrasting thick and thin strokes are achieved by using a broad-edged tool.

Oval counter spaces

10-degree letter slant

Descenders are slightly shorter than the x-height

Ascenders are slightly shorter than the x-height

Low branching

Counter spaces are about equal width

Exit strokes reach up about ⅔ x-height to give lettering a cursive look

Subtle hook serifs

Contrasting thick and thin strokes

Letter Spacing

iloevra

The spaces between letters are about the same as the counter spaces within the letters.

Letter Construction

1 Maintaining a 30-degree pen angle for all strokes, start by making a short hairline before rounding the top and making a downstroke at a 10-degree slant.

2 With the nib overlapping stroke 1 just above the baseline, create a branching stroke by moving upward and to the right. At the top guideline, drop over and down, parallel to stroke 1. Pull slightly left and end with a thin line, about 1 nib width above the baseline.

3 Place the nib within stroke 1 so that it sits just above the baseline. Make a short curved stroke that ends with a thin line, overlapping the end of stroke 2.

1 Maintaining a 30-degree pen angle for all strokes, move a little left before making a slightly curved downstroke at a 10-degree slant. Bounce upward and to the right; end just below the top guideline.

2 Place the nib so that it overlaps stroke 1 and pull right to make a short horizontal stroke.

3 Begin at the top guideline and make a vertical stroke that overlaps the end of strokes 1 and 2 and runs parallel to stroke 1. Just before reaching the baseline, rotate the penholder between thumb and forefinger while pulling right and upward to create the exit stroke.

Alphabet 20: Italic capitals

This elegant uppercase alphabet is designed to accompany lowercase Italic (pages 90–91). The exemplar demonstrates the use of flourishes, but all the letters can be made with a simple hairline serif. Flourishes should be used sparingly and only at the beginning of a line or text block rather than within a body of text.

Tools

- 2-mm square-cut nib
- Straight penholder
- Gouache

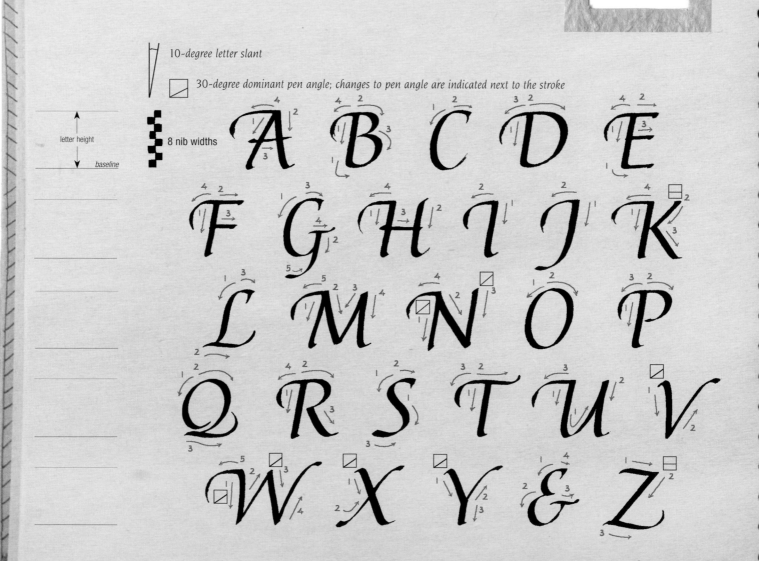

10-degree letter slant

30-degree dominant pen angle; changes to pen angle are indicated next to the stroke

letter height
baseline

8 nib widths

Distinguishing Features

These letters are 8 nib widths high and written on a 10-degree slant. The alphabet is based on an oval shape, but the bowls of B, D, P, and R carry their weight a little above center. First downstrokes are softened by the addition of a modest, rounded heel at the baseline, while second downstrokes have a larger rounded exit stroke. A simple hairline serif should be used in most cases, but graceful flourishes provide a beautiful decorative alternative. A light touch is required for the elegant, right-side diagonals on V, W, X, and Y.

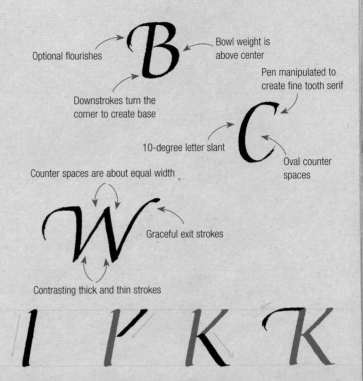

Optional flourishes

Bowl weight is above center

Downstrokes turn the corner to create base

Pen manipulated to create fine tooth serif

10-degree letter slant

Oval counter spaces

Counter spaces are about equal width

Graceful exit strokes

Contrasting thick and thin strokes

Letter Construction

1 Maintaining a 30-degree pen angle for all strokes, start by making a short hairline serif and then round the top to make the downstroke on a 10-degree slant. Just before the baseline, make a soft turn to the right and end with a thin line.

2 Place the nib at the top of stroke 1 and pull right and around, ending a little above mid-height. This stroke ends before meeting the downstroke.

3 Position the nib so that it overlaps the end of stroke 2; pull right and then around the curve. End with a thin line, overlapping the end of stroke 1.

1 Using a 30-degree pen angle, make a short hairline and then round the top to make a downstroke on a 10-degree slant. Just before the baseline, pull slightly right to create a rounded heel.

2 Position the nib at the top guideline at a 0-degree (horizontal) pen angle, so that the letter width will be about half the letter height. Pull a diagonal, ending at about mid-height and not quite touching the downstroke.

3 Return to a 30-degree pen angle to complete the letter. With the nib overlapping the end of stroke 2 and just kissing the downstroke, pull a diagonal stroke to the baseline. Soften the exit with a subtle pull to the right before lifting the nib.

4 Position the nib over the top of stroke 1 and pull to the left. To finish, rotate the penholder counterclockwise between thumb and forefinger and taper downward.

Letter Spacing

Ro Li Va

The space between capital and lowercase letters is about the same as the counter space within the lowercase n.

Borders and Embellishments:
Italic

Italic is a popular classic letter style that works well with simple borders or additional imagery. The people you love deserve encouragement and recognition for all the accomplishments and bold adventures of their lives: graduation, a new job, exotic trips, new home, or religious ceremonies.

▼ Calligraphic borders
Create borders from repeated calligraphic strokes made with the same pen used for the Italic lettering.

▲ Bon voyage
This geometric boat shape makes a good image for cutout-style cards or embossing.

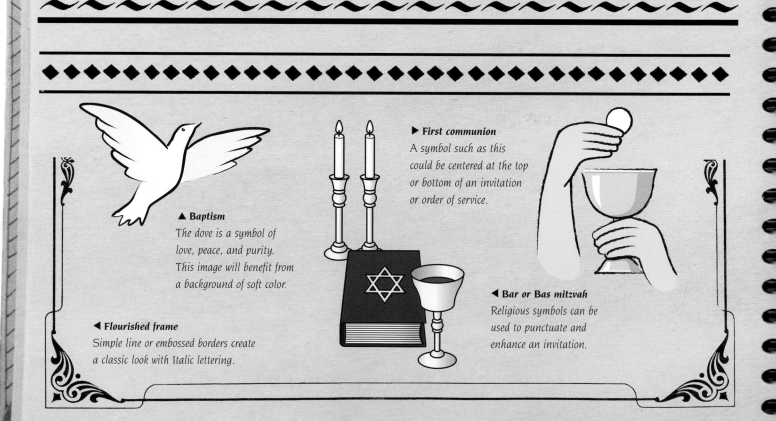

▲ Baptism
The dove is a symbol of love, peace, and purity. This image will benefit from a background of soft color.

► First communion
A symbol such as this could be centered at the top or bottom of an invitation or order of service.

◄ Flourished frame
Simple line or embossed borders create a classic look with Italic lettering.

◄ Bar or Bas mitzvah
Religious symbols can be used to punctuate and enhance an invitation.

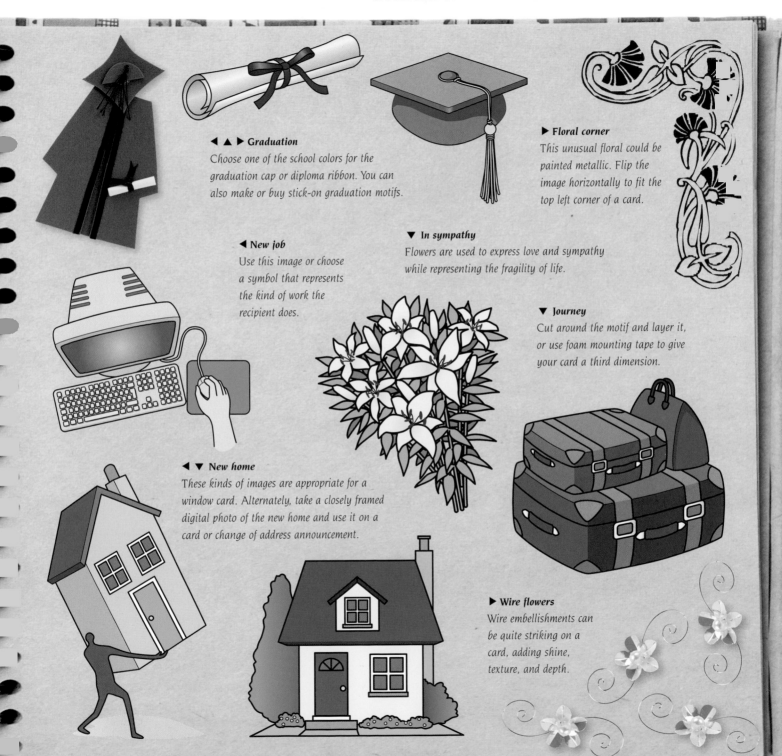

◀ ▲ ▶ Graduation

Choose one of the school colors for the graduation cap or diploma ribbon. You can also make or buy stick-on graduation motifs.

▶ Floral corner

This unusual floral could be painted metallic. Flip the image horizontally to fit the top left corner of a card.

◀ New job

Use this image or choose a symbol that represents the kind of work the recipient does.

▼ In sympathy

Flowers are used to express love and sympathy while representing the fragility of life.

▼ Journey

Cut around the motif and layer it, or use foam mounting tape to give your card a third dimension.

◀ ▼ New home

These kinds of images are appropriate for a window card. Alternately, take a closely framed digital photo of the new home and use it on a card or change of address announcement.

▶ Wire flowers

Wire embellishments can be quite striking on a card, adding shine, texture, and depth.

Adam

Birgitta

Antonio Pedro

Matthäus

Matthoi

Nicolao

Core Techniques

This chapter provides basic instructions for measuring, cutting, and folding, as well as a variety of embellishment techniques, from embossing and stamping to layering and making envelopes. Mix and match techniques to create unique cards, invitations, place cards, and party favors.

Making a card

You can buy ready-made cards, but it is very straightforward to make your own as long as you measure accurately and cut carefully. Make sure that your line of sight is directly over the ruler in order to achieve this.

Tools

- Nonslip metal ruler
- Sharp pencil
- Self-healing cutting mat
- Craft knife
- Scissors
- Set square (optional)
- Mid-sized pointed paintbrush (#4–6)

Cutting lines

1 Measure as before, but instead of marking the measurements with a pencil dot, mark them with the tip of a craft knife. Place the blade in each mark in turn and move the ruler up to the tool.

2 Hold the ruler firmly near the center with one hand, making sure that no part of your hand overhangs the cutting edge of the ruler, and cut along the edge with the craft knife.

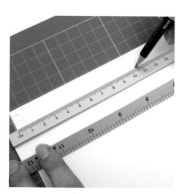

Measuring

1 Draw a small arrow to indicate the starting edge for the measurements so that you will not lose track of it. Measure the required distances and mark each one with a fine dot.

2 Use a set square to ensure a 90-degree angle where necessary. Placing the pencil tip on each dot in turn, move the ruler up to the pencil and lightly draw lines to connect the dots.

3 A lighter touch and several passes with the blade will produce better results than trying to cut through card stock by putting a lot of pressure on the knife. Use the tip of the blade to move cut paper away from the ruler. This ensures that the cut is complete before you move the ruler.

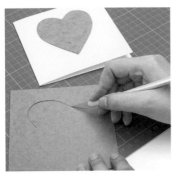

Cutting shapes

Curves
Transfer the outline of the shape onto the card (see page 102). Carefully cut around any curved lines with a craft knife, turning the paper as you go.

Angles
Make a small prick mark at the angled corner. When the knife blade reaches the prick mark, stop and leave the tip of the knife in place, then rotate the card and continue with the cut.

Tearing

1 Measure as before, and line up the ruler so that it rests on the side of the paper you want to keep. Wet a paintbrush and run it along the edge of the ruler. Keep the ruler in place and allow the water to soak into the paper for a few seconds. Long runs may require rewetting the brush.

Cutting tip
Make a template for symmetrical shapes out of bond paper. Fold the paper in half, cut half the shape, then unfold.

Snowflakes
Use a square of lightweight paper for snowflakes. Fold it in half vertically and horizontally, then fold in half again diagonally. Using scissors, cut away shapes from the paper.

2 Gently and slowly tear the paper, keeping the ruler in place if it helps. Long-fibered papers will result in a more feathered torn edge than short-fibered papers.

3 If you wish to color the torn edge, move the ruler in from the torn edge by about ¼ inch (5 mm) and use the paintbrush to apply watercolor or gouache.

Scoring and folding

Bond and other lightweight papers usually fold well without being scored, but it is recommended that card stock and heavier papers be scored before folding.

Tools
- Bone folder
- Nonslip metal ruler
- Set square (optional)

1 Measure and mark the fold line with small indents using the point of a bone folder. Use a set square if necessary to ensure a square fold. Place the bone folder on the marks, move the ruler up against the tool, and score along the fold line. You should just be indenting the surface.

2 Carefully align the edges of the paper and hold firmly with one hand. Use the straight edge of the bone folder to flatten a small area at the center of the fold. Working out from the center in both directions, flatten the whole fold.

Basic folds

There are many different ways of folding cards. Here are some suggestions:

◄ Standard fold

◄ Standard fold with diagonal front piece

◄ Double-layered card, known as a French fold

◄ Duofold card with overlapping front, sometimes referred to as a letter fold

◄ Duofold card with flaps that meet at center front, called a wingfold

◄ Upright concertina duofold card

▲ Horizontal concertina

Folding tip
Some papers become shiny along the fold line, so cover the area of the paper to be folded with a clean sheet of bond paper first.

Layering

Several sheets of paper can be layered together to provide interesting texture and stunning color combinations. This is a great way of creating frames and borders. Exotic Japanese papers can also be used to create beautiful and sophisticated results. Delicate tissues and translucent papers layered over lettering or photographs arouse the viewer's interest.

Straight-edged frame

Layer several sheets of paper together, with the smallest on top. This can be used as a frame for lettering and other motifs, or as a focal embellishment.

Vertical border

Cut a piece of contrasting paper that is ½–1 inch (1–2.5 cm) narrower than the front of the card and position it either flush right or flush left to create a vertical border.

Gluing layers

When applying glue, place the paper or card stock onto scrap paper. The pages of an old telephone book would be ideal; simply turn the pages to make sure that you are always working on a clean surface. Work out toward the edges of the paper, using just enough glue to hold the pieces together. Allow glued layers to dry under the weight of a book to keep them flat. Lightweight papers only need to be "tipped" in, by applying glue only across one edge of the paper you want to adhere.

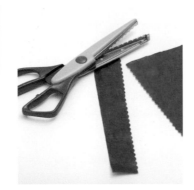

Feathered or scalloped frame

Tear papers for layers of feathered edges, or use pinking shears or craft scissors with a scalloped blade to create decorative edges and layer them over straight-cut edges.

Lining

Line the inside of the card with a contrasting text-weight paper cut ⅛ inch (3 mm) smaller all around. Glue the lining in place, either completely or at the center fold only.

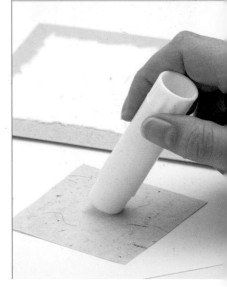

Embellishing techniques

There are many different embellishing techniques you can use. You can draw motifs freehand or trace them; use punches or rubber stamps; or emboss images onto the card. You can also embellish the card with exciting wet media effects.

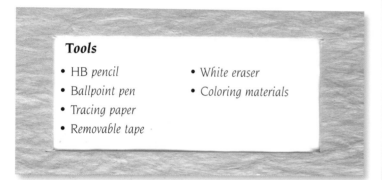

Tools

- HB *pencil*
- *Ballpoint pen*
- *Tracing paper*
- *Removable tape*
- *White eraser*
- *Coloring materials*

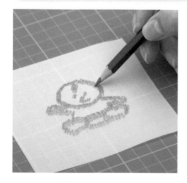

Transferring an image

1 Draw or trace the outline of the image or lettering onto tracing paper with an HB pencil. Flip the paper over and scribble over the back of the outline.

2 Position the image, right side up, on the card and tape in place. Use a ballpoint pen to trace over the entire image. Use a red pen for better visibility.

3 When you remove the tracing paper, you will see that the graphite from the back of the image has transferred onto the card. Go over the lines of the image with a pencil or pen, as required. Allow any ink to dry, then erase the graphite lines and add extra color to the image if you wish.

Windows

Windows are an intriguing element in card design. They can be large or small, in a corner or centered. There can be just one or several. You can outline them with a loose hand-drawn line, with a carefully ruled line, or emboss around them. Windows can reveal a complete image or show only a small portion of a larger, hidden image. Things can poke out through a window. You can leave a flap hinged on one edge so that the viewer needs to open the window to see what is inside. You can put a translucent layer of Japanese paper or vellum behind a window to tease the viewer. Windows can be square, rectangular, round, or oval; you can cut them with a craft knife or use a punch.

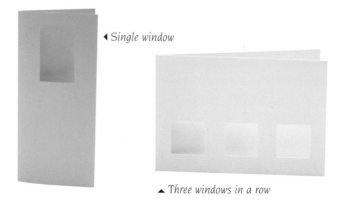

◀ *Single window*

▲ *Three windows in a row*

Punches

Punches are easy to use and readily available in craft stores. Remember that both the negative space (the hole) and the positive shapes (the pieces that have been punched out) can be used.

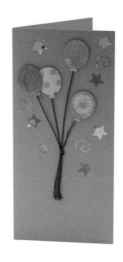

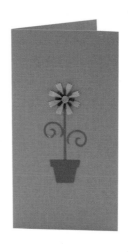

Decorative papers
Punch shapes from decorative papers and attach them to solid-colored card stock, or use decorative card as a background for images punched from solid colors.

Create a picture
Use a series of punched shapes to create bouquets, gardens, or patterns.

Punched border
Make a border by punching a line of one or more images, and layer it over a paper of contrasting color.

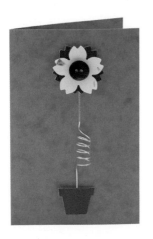

Three-dimensional combinations
Combine punched images with embellishments such as brads, sequins, wire, buttons, or stickers.

Positive/negative shapes
Combine the positive and negative shapes you have made with the same punch or with different punches.

Embellish images
Punch shapes from colored papers and incorporate them into stamped or hand-drawn designs.

Rubber stamping

Commercial stamps are readily available for purchase in specialty shops, craft stores, and online. You can have your own lettering, monogram, or drawings made into a rubber stamp by custom rubber stamp manufacturers. Alternately, use white erasers or pieces of rubber sold in craft stores to make your own rubber stamps. Begin with a simple image to gain some experience.

Tools

- HB *pencil*
- *Permanent fine-line marker*
- *Tracing paper*
- *White eraser*
- *Craft knife*
- *Inkpad*

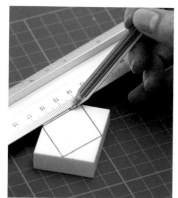

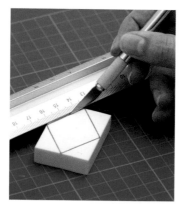

1 Draw or trace an image onto the eraser. After tracing an image, remove the tracing paper and redraw the image with a permanent fine-line marker.

2 Use a craft knife or other fine-tipped cutting tool to score the image into the rubber (a variety of cutting tools are available at craft stores).

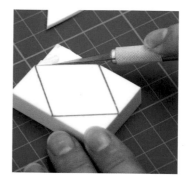

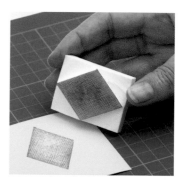

3 Gradually remove layers of rubber from around the image. Never undercut the image, and always angle cuts slightly outward. Take care not to cut too deeply around fine lines and small designs because it may cause parts of the image to be unstable and break off.

4 Ink and test the stamp as you go along by gently but firmly pressing it down onto a piece of card stock. Do not rock the stamp, because this may cause the edges to leave an unwanted impression. Remove more rubber as required. If necessary, try padding your work surface with several sheets of newsprint to compensate for slightly uneven pressure. Clean the stamp after each test.

5 It is a good idea to draw guidelines on the back of the stamp to indicate useful reference points. Use these guidelines to help you align the stamp as required.

Stamp effects

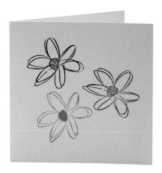

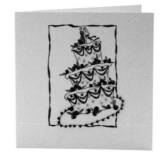

Stamping tips
When making your own rubber stamps, remember that the image on the stamp will be reversed when it is stamped. This does not matter with symmetrical designs, but take care with nonsymmetrical images and lettering.

Varying intensity
Stamp multiple images without reinking. Use dye-based inkpads for quicker drying times, and pigmented inkpads for slower drying times.

Color and decoration
Once stamped images are dry, color them with colored pencils or markers. You can also add decorative elements, such as beads, eyelets, or stickers, to enhance the images.

Stamped border
Create a border of motifs or shapes by stamping the same image in different colors.

Combine motifs
Combine one or two smaller motifs to create different patterns or designs.

Three-dimensional effects
Cut out stamped images and apply them to the card using a foam mounting pad or spring pop-up (see page 111) for three-dimensional effects.

Layered three-dimensional effects
Stamp the image onto paper and carefully cut it out. Stamp the image onto the card and let it dry, then stick the cutout image on top with a foam mounting pad.

Wet embossing

Raised or shiny images can be created with embossing powder. Be sure to use slower drying pigmented inks.

Tools

- Rubber stamp
- Pigmented inkpad
- Embossing powder
- Heat gun

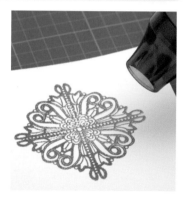

1 Press a rubber stamp onto a pigmented inkpad and then stamp onto the card. Shake a generous amount of embossing powder over the wet stamped image, making sure that the whole image is covered. Pour the excess powder back into the jar. Gently tap the back of the card to make sure all excess has been removed.

2 Heat the powdered image with a heat gun until it becomes glossy. Overheating will cause the image to spread.

◀ Wet embossed card

Dry embossing

This is a very elegant technique that can be used to create raised or indented effects. Templates are available in craft stores, or you can make your own. To create a raised image, use a template where the image forms a negative (open) space. To create an indented (debossed) image, use a template with a positive (raised) image.

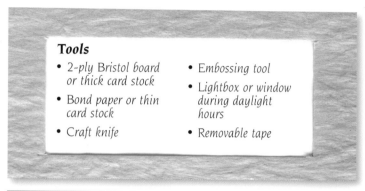

Tools

- 2-ply Bristol board or thick card stock
- Bond paper or thin card stock
- Craft knife
- Embossing tool
- Lightbox or window during daylight hours
- Removable tape

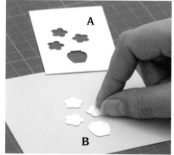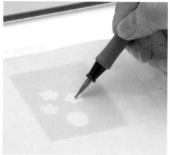

1 An easy way to make embossing templates is to punch shapes out of Bristol board. The punched board will form a template for a raised image (A). Stick the punched shapes onto bond paper or thin card stock to form a template for an indented image (B).

2 For a raised image, tape the template (A) face down against a light source, with the card face down on top. Using an embossing tool, move methodically and slowly around the inside edges of the image. Firm pressure is required. You may need to go over some areas more than once.

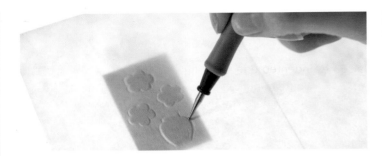

3 For an indented image, position the template (B) and card in the same way as before, then move the embossing tool slowly and firmly around the edges of the shapes, going over some areas several times if necessary.

◀ *Indented dry embossed card*

▲ *Raised dry embossed card*

Wet media

Use quality art papers for decorating with wet media, and experiment with acrylic inks, watercolors, and different-sized brushes and rollers to discover the many effects you can achieve. There is no need to fill the entire sheet of paper with color. These papers can also be used for collage, punches, layering, and borders.

Water mister
Use a mister or atomizer to wet the paper, then add color to a few of the wet areas. Mist again to move color or reduce intensity.

Dry brush
Use a dry brush to paint broad strokes on dry or wet paper for different effects.

Salt
Sprinkle coarse salt on wet ink and allow the ink to dry before brushing the salt off.

Marbling
Buy a suminagashi kit for simple marbling.

Tie-dye
Fold paper into segments and dip the corners into color for a tie-dye look.

Spatter
Dip an old toothbrush or paintbrush into ink and pull a thumb across the bristles for a spatter effect.

Color tips
Use acrylic inks for more intense color, and watercolor for subtler effects. You may find that acrylic inks are more pleasing when they have been watered down. Add metallic or iridescent inks and paints for shimmer. Wash brushes thoroughly before acrylic inks begin to dry.

Decorated capitals

A bold capital letter at the beginning of a text block or line of lettering is a great way to catch the viewer's attention. Decorated capitals combined with beautiful hand-lettered text and a simple border can offer enough visual interest without additional illustration or embellishments. Alternately, you could simply pepper the text with colorful capital letters.

Simple ideas

There are many simple ways to change or enhance a letter so that it becomes the focal point of a card.

Outline
Outline the letter in the same color, or in a different color for more impact.

Dots
Outline and decorate the letter with dots.

Doodles
Fill an outlined letter with doodles.

Gold gouache
Add gold gouache between the lines of double-stroked letters, or fill counter spaces with gold.

Frame
Draw a frame around the letter and fill with gold or a contrasting color.

Flourish
Add a flourish, a simple line, and a dot or two.

Embossed
Emboss the letter shape.

Stylized
Use a large, modern, or stylized capital for the recipient's initial or the first letter of a couple's surname.

Other ideas

Make the first letter larger, drop it below the baseline, and justify the text block around it. Try coloring the letter differently from the other text, or use a contrasting letter style. Use marker, pencil, or watercolor to add color between all the letters of the first or only word. Cut the letter out and attach it with a piece of mounting tape so that it is raised above the surface. Cut out a large, bold letter and allow a contrasting colored paper to show through the card from below. Cut your own rubber stamp alphabet to use as accent letters that dance within the text. Once the letters are dry, add a row of dots to the downstroke.

Gilding

Gold leaf within a piece of lettering catches the eye and creates a rich decoration. Gold leaf is often more effective if used sparingly, and is ideal for capital letters. Gold leaf is expensive, so use it for special cards and stationery only. Gesso provides a raised surface to which gold leaf adheres well, but the application requires a good level of skill. Gum-based gilding is simpler.

Tools
- 50:50 *solution of PVA and distilled water*
- *Paintbrush*
- *Craft knife*
- *Gold leaf*
- *Agate burnisher*

3 Breathe on the dried gum through a tube of paper to make it moist, and then place a piece of gold leaf over the letter immediately, pressing it down firmly with a finger. Rub over the backing paper and gum with a burnisher.

4 Peel back the sheet of transfer gold. If the gold has not adhered properly, repeat step 3.

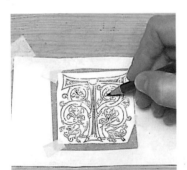

1 Tape the card to a flat surface and lightly outline the letter to be gilded. Here, a detailed paper transfer letter is being used. Simply trace around the design with a pencil.

2 Apply the gum mixture to selected areas of the letter with a fine paintbrush. Allow to dry overnight in a dust-free environment, then remove any unwanted solution with the point of a blade.

5 Leave for about 30 minutes, then gently burnish the gold. Finish decorating the rest of the letter.

Additional embellishment
Add extra sparkle to gum-based gilding by making regular indentations in the finished gold with a clean, blunt point. Paint the main body of the letter in a strong color around the gilding to ensure clean edges to the gold. You can also try lettering whole words by loading your pen with shell gold mixed with a few drops of distilled water. Burnish the lettering once it has dried.

Cutouts and pop-ups

Images or words on the front of a card that are cut out so that they overhang the section behind have extra impact. A pop-up is a section of the card that moves forward and sits above the surface.

> **Tools**
> - Nonslip metal ruler
> - Pencil
> - Self-healing cutting mat
> - Craft knife
> - Scissors
> - Bone folder
> - Set square (optional)
> - Glue

Cutouts

This example demonstrates how to make a cutout on a duofold card.

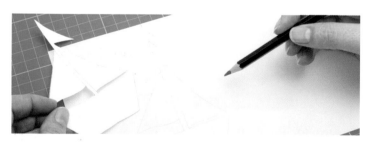

1 Cut out the basic card, and measure and mark the two fold lines. Here, the two front panels are each ⅔ the width of the back (third) panel. This ensures that the cutout image will be supported. Transfer the image onto the card so that it crosses over the first fold line. Make sure that the image will not overhang the back (right-hand) panel when the card is folded.

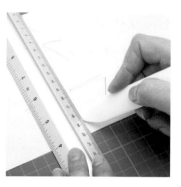

2 Cut around the portion of the image that is on the right-hand side of the first fold line. Do not cut on the left side of the fold line.

3 Score the first fold line above and below the image; do not score through the image. Score the whole of the second fold line.

4 Fold along both fold lines so that the portion of the image that has been cut out will extend beyond the first fold when the card is closed.

5 Decorate the image as required. Here, patterned papers are glued onto the image.

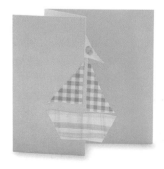

▶ *Sailboat cutout on a duofold card*

Spring pop-up

This is a simple paper device used for raising an appliqué image above the surface of a card.

1 Cut two strips of paper. Begin with ½ x 5-inch (13 x 125-mm) strips. The size may vary, depending on the size of the appliqué. Position the strips at 90 degrees to each other, and glue together where they overlap.

2 Fold one strip over the other. Continue alternately until the length of the strips is used up. Trim the end of the last strip even with the square end of the spring. Glue the ends to secure.

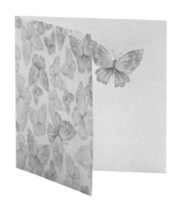

3 Apply glue to the top of the spring and stick the spring to the appliqué. Glue the bottom of the spring to the card.

▲ *Butterfly spring pop-up*

Folded pop-up

The most basic folded pop-up is a symmetrical shape, such as a heart. You will need a lined card, with the inner card ⅛ inch (3 mm) smaller all around than the outer card. Use card stock for the outer card and text-weight paper for the inner card. Do not attach the two layers together yet.

1 Fold the inner card in half and transfer the image so that the center of the image sits on the fold. Mark one or more short vertical lines where the image will remain attached.

2 With the card still folded, cut around the shape. Do not cut the vertical lines. Lightly score the uncut vertical lines at the sides of the image.

▼ *The folded pop-up heart stands above the center fold when the card is open. Color or decorate the pop-up image for more impact.*

3 Open the card and refold so that the image pops up. Glue the inner and outer cards together, taking care not to glue the pop-up.

Box pop-up

This technique involves attaching an appliqué motif to a raised box inside the card. You will need a lined card for this technique, with the inner card ⅛ inch (3 mm) smaller all around than the outer card. Use card stock for the outer card and text-weight paper for the inner card. Do not attach the two layers together yet.

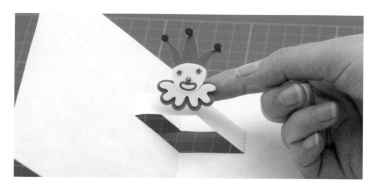

4 Glue an appliqué image to the face of the box. Glue the inner and outer cards together, but make sure that you do not apply glue to the box pop-up.

1 Fold the inner card in half and decide where you want the pop-up, making sure that it is positioned so that the appliqué will be inside the card when the card is closed. Make a set of pencil marks to indicate the dimensions of the box. Draw horizontal pencil lines to indicate where you will need to cut.

◄ Choose a color from the appliqué motif to make the outer card.

2 Cut along the horizontal lines, then score a vertical line to join the cuts.

3 Fold the resulting tab forward and back on the score lines. Open the card and push the tab inward to form a box.

▶ Make a card with a series of box pop-ups; three is the maximum for most card sizes. Vary the size of the boxes so that they stand at different heights, but be sure to leave enough room between the boxes to accommodate the appliqué.

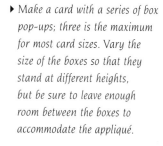
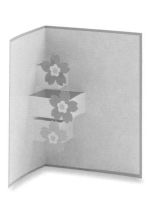

Envelopes

A special handmade envelope is easy to make, and is the perfect finishing touch for a one-of-a-kind card. Match the theme of the card by using the same colors, border, or motif.

Tools
- Bond paper
- Pencil
- Nonslip metal ruler
- Lightbox

3 Fold in the side flaps, then glue the side edges of the bottom flap to them. Stick double-sided tape below the edge of the top flap to make a seal.

Envelope tips
Make a feature of the recipient's name by writing it larger, in a different color, or outline the letters and fill with pattern. Complete the address in tidy printing. If you are concerned about smudging, run a block of paraffin wax (the kind used for preserving) across the width of the envelope to seal the address. Alternately, spray it with fixative.

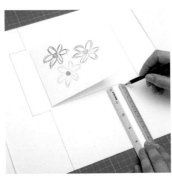

Making an envelope

1 The basic square or rectangle should be slightly bigger than the card. Add a bottom flap ¾ of the basic height plus ½ inch (1 cm). Add a top flap ¼ of the basic height plus ½ inch (1 cm). Add 1¼-inch (3-cm) side flaps. Draw the shape onto the paper.

2 You can add a decorative lining paper the height and width of the envelope minus the side and bottom flaps. Glue it in place before you assemble the envelope. Use a coin to draw curves at the corners of the side flaps. Gently taper the top and bottom flaps.

Addressing envelopes

When there are many addresses to be written on same-sized envelopes, a master liner and lightbox can save a lot of time and effort. This technique works best for unlined envelopes, so that more light can shine through.

1 Cut out a piece of bond paper that will slide easily in and out of the envelope. Determine the placement of the address and mark guidelines for the lettering (see page 16).

2 Place the liner inside the envelope on a lightbox. You can letter directly onto the envelope on top of the lightbox, or draw guidelines onto the envelope if you prefer.

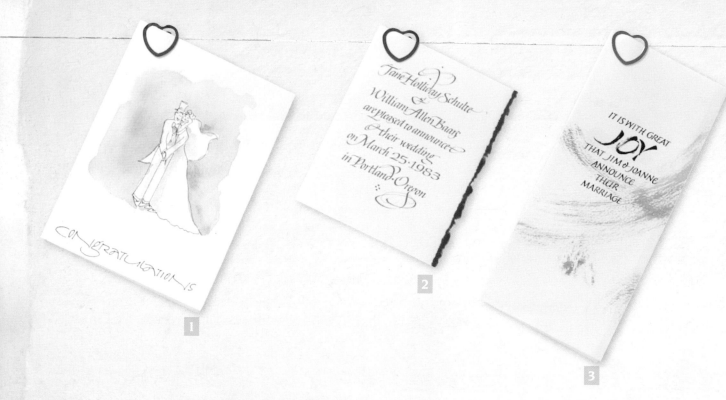

Gallery

A selection of handmade cards, invitations, and special-occasion paper crafts from professional calligraphers.

1 Wedding card by Linda Prussick

The original line drawing is framed and accented by a watercolor wash and subtle shadowing. A single line of monoline lettering anchors the image, creating a lovely, one-of-a-kind, single-fold card.

2 Wedding announcement by Eliza S. Holliday

The beautiful italic lettering, with lively, well-placed flourishes, is centered and printed on a decal-edged card. A graceful ampersand is the perfect conjunction to join the names of the bride and groom. Color is brushed onto the decal edge to match the text, and a few gold dots are added to complete the design.

3 Wedding announcement by Ruth Booth

Broad brushstrokes of gold gouache provide a decorative background for text that has been hand-lettered and then arranged on a computer. Additional visual interest is created by the use of contrasting alphabet styles; the enlarged word "Joy" is an effective focal point. The duofold design allows for easy one-sided printing.

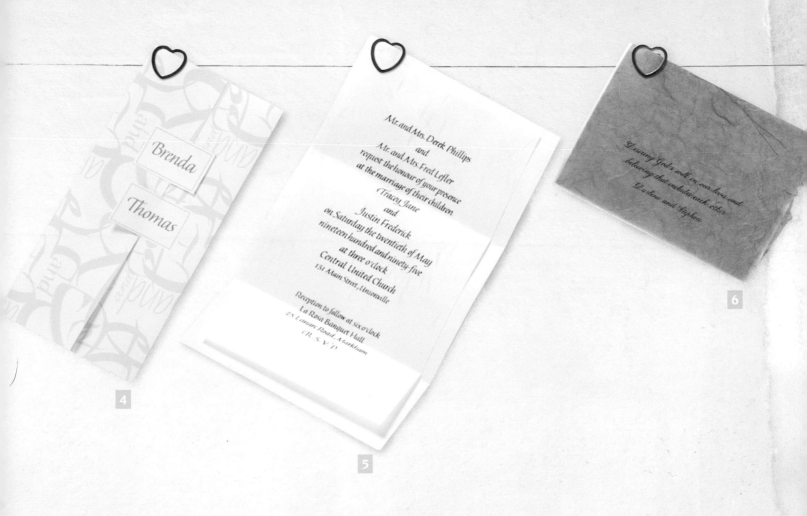

Brenda

Thomas

Mr. and Mrs. Derek Phillips
and
Mr. and Mrs. Fred Lefler
request the honour of your presence
at the marriage of their children
Tracey Jane
and
Justin Frederick
on Saturday the twentieth of May
nineteen hundred and ninety-five
at three o'clock
Central United Church
131 Main Street, Unionville

Reception to follow at six o'clock
La Rosa Banquet Hall
25 Lanier Road, Markham
(R.S.V.P.)

4 Wedding invitation by Ruth Booth
This unique wingfold card is held shut by two
carefully cut flaps bearing the names of the bride
and groom. The background image is a collection of
hand-lettered ampersands, cleverly fit together by
creative partner Linda Prussick, to create a block
that can easily be repeated for an all-over pattern.

5 Wedding invitation by Lynn Lefler
Superb italic lettering in a classic centered layout
is used here to create a simple and elegant duofold
invitation. The text is reduced and photocopied
onto a machine-made Japanese paper that is
folded within a slightly larger piece of exquisite
handmade Japanese paper.

6 Wedding invitation by Lynn Lefler
Three lines of graceful copperplate lettering are
reduced and photocopied onto delicate Japanese
paper. Layered papers of contrasting color have
an intriguing texture, and the unusual placement
of the text makes the design more interesting.
Two layers of paper allow for single-sided copying.

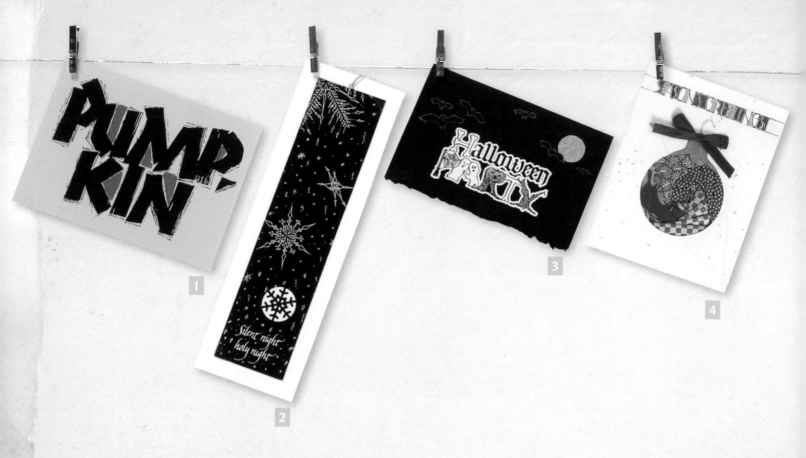

1 Halloween postcard by Eliza S. Holliday

Bold black lettering becomes even more spirited with the addition of irregular fine lines around its edges. Vibrant orange paint highlights the "Pumpkin" counter spaces, and it is all tied together by the tinted card stock.

2 Christmas card by Lily Yee

Hand-drawn snowflakes and italic lettering are inverted on a computer to create a white-on-black print, then highlighted with a punched snowflake. The print can be removed from the background white card stock and hung as an ornament from the silver cord.

3 Halloween party invitation by Ruth Booth

The text is lettered onto white paper, cut out, and positioned on black decal-edged card stock. Bats are hand-drawn with white pencil. One bat wing is cut out and imposed on top of an orange moon cut from decorative paper.

4 Christmas card by Cherryl Moote

An iris-fold design of Japanese papers is attached behind the cutout shape of a tree ornament. The front of the card stock folds inward to hide the back of the papers. A bow and piece of wire complete the ornament, and the monoline text is enhanced with color.

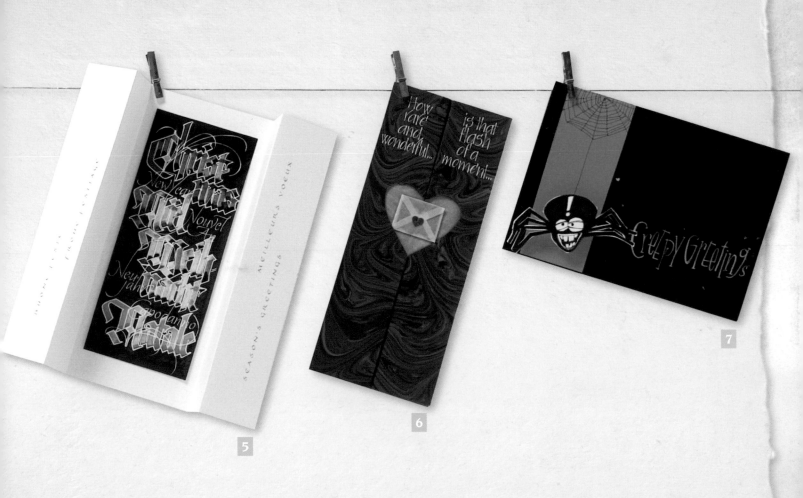

5 Christmas card by Mark Lurz

The delicate calligraphic capitals on the two front panels of this intriguing card invite the viewer to open the shutters and reveal a colorful, multilingual Christmas greeting. Fine, white, monoline lettering contrasts with the large outlined and hand-colored greetings. The inside panel is a color photocopy adhered only at the top edge.

6 Valentine card by Julie Gray

Decorative marbled paper is folded four times to create this unusual card; the folds open up like those in card 5 to the left. A symmetrical heart-shaped window reveals a little, translucent vellum envelope that is sealed with a tiny red heart. Bleed-proof white gouache is used to letter the delicate but easy-to-read text.

7 Halloween card by Linda Prussick

The strip of bright orange paper adds contrast and gives the crazy pop-up spider extra emphasis. A hand-drawn spider web and tiny hearts are added for visual interest. Large playful lettering is done with bleed-proof white gouache so that it can be read easily on the black card stock.

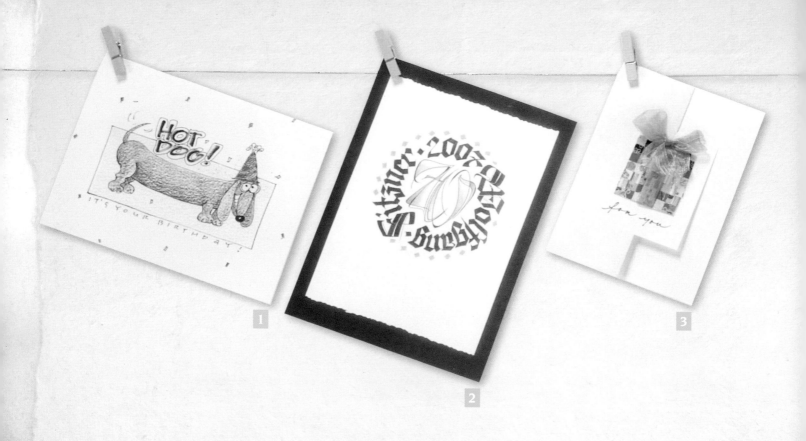

1 Birthday card by Linda Prussick

This humorous hand-drawn image echoes the horizontal card format and is combined with a clever caption. The dog's hat and tail, as well as the bolder lettering, break through the loosely drawn line border to create a more dynamic design. Scattered confetti adds color and interest to the otherwise plain background.

2 70th birthday card by Mark Lurz

A stylized and decorative "70" is encircled by contrasting bold lettering to create a strong visual unit. Pale blue diamonds tie in with the shading in the central numeral, while the soft torn edges at the top and bottom remind us that this is a handmade card. Dark card stock supports and frames the artwork to complete the design.

3 Gift card by Cherryl Moote

This bargello mosaic is transformed into an extravagant-looking gift by the addition of a generous sheer ribbon and bow. The gift and tidy handwritten text extend onto the cutout so that they are centered on the front of the duofold card, inviting the viewer to open the card and see what is written inside.

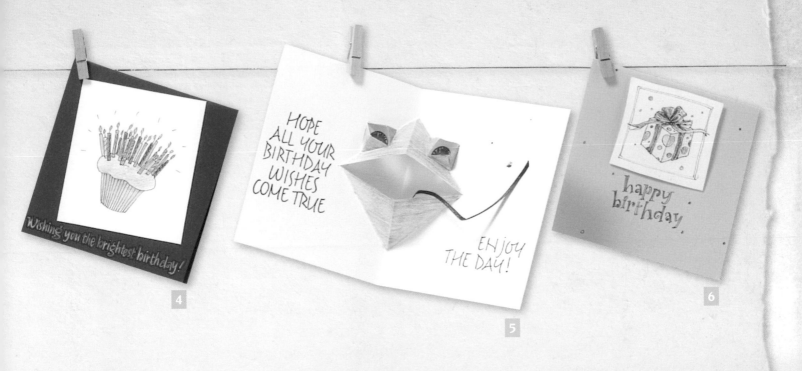

4 Birthday card by Linda Prussick

A lighthearted greeting anchors the image of an unlikely cupcake ablaze with colorful birthday candles. The line drawing is filled in with colored pencil, cut out, and mounted at an angle onto the dark-colored supporting card stock.

5 Pop-up birthday card by Ruth Booth

A French-fold card structure enables this delightful pop-up. The frog is colored green, the eyes gold, and little flies are added to emphasize the third dimension. A red ribbon extends from inside the mouth to suggest a tongue and add a splash of bright color. Quipster-style lettering is used to convey the birthday greeting.

6 Birthday card by Linda Prussick

Brightly colored card stock adds life to this simple design. The ends of the ribbon break through the loosely drawn line border, while scattered dots echo the gift-wrap pattern and suggest movement. The central image is cut out and mounted with foam tape to add dimension. Outlined lettering is filled with the same colors used in the image.

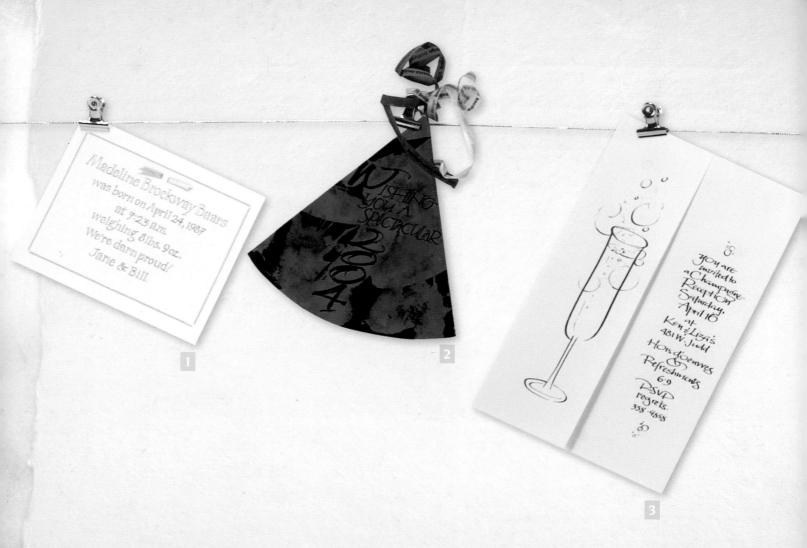

Madeline Brockway Baars
was born on April 24, 1987
at 7:23 a.m.
weighing 8 lbs. 9 oz.
We're darn proud!
Jane & Bill.

1

WISHING YOU A SPECTACULAR 2004

2

You are
invited to
a Champagne
Reception
Saturday,
April 16
at
Ken & Lisa's
481 W. Judd
Hors d'oeuvres
& Refreshments
6-9
RSVP
regrets.
338-4858

3

1 Birth announcement by Eliza S. Holliday

This lettering is fashioned after a very legible alphabet style that is traditionally used for children's text, but here it is rendered in outline to give it a more delicate look. The soft-pink ruled border contains and brightens the announcement, while the sweet little ribbon adds a touch of love.

2 New Year's greeting by boothprussick design

A New Year's greeting in the form of a party hat. The bold, high-contrast colors in the hand-decorated paper provide a background for contrasting bold and fine stylized lettering. The hat is printed and cut out, then cascading streamers are attached to the top before folding.

3 Anniversary party invitation by Eliza S. Holliday

The calligraphic nature of the line quality infuses this invitation with a professional edge, balancing the casual attitude of the drawing and lettering. The decorative bubble groupings above and below the text tie in beautifully with the champagne image and the theme of a celebratory party.

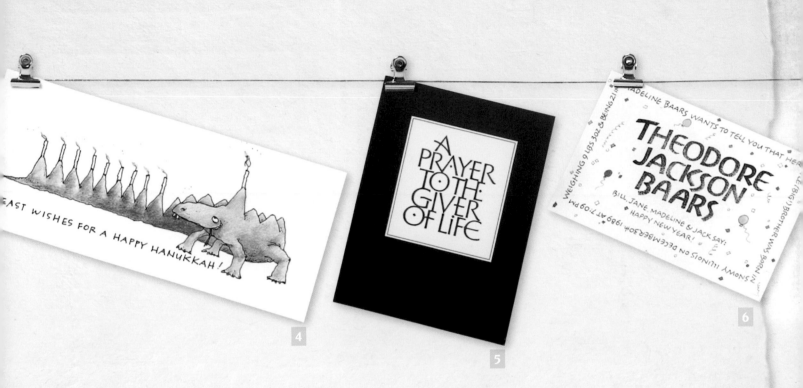

EAST WISHES FOR A HAPPY HANUKKAH!

A PRAYER TO THE GIVER OF LIFE

THEODORE JACKSON BAARS

BILL, JANE, MADELINE & JACK SAY: HAPPY NEW YEAR!

WEIGHING 9 LBS. 3 OZ. & BEING 21"

MADELINE BAARS WANTS TO TELL YOU THAT HER LITTLE (BIG!) BROTHER WAS BORN ON A SNOWY ILLINOIS ON DECEMBER 30th, 1989 AT 7:09 P.M.

4 Hanukkah card by Linda Prussick

This delightfully long character is a wonderful image for a horizontal format. The hand-drawn image is outlined with fine-line marker and filled in skillfully with colored pencil. Amusing details, such as the rolling eye, front teeth, and long tongue, are coupled with lively monoline capitals to express a humorous greeting.

5 Sympathy card by Michael Clark

The thoughtful nature of this design supports the solemn sentiment that it carries. Carefully constructed letters are designed to form a strong visual unit that is contained by a precise fine line. The lettering is showcased by a generous, matching blue background and modestly decorated with carefully placed diamonds.

6 Birth announcement by Eliza S. Holliday

Streamers, brightly colored balloons, and confetti provide a cheerful and active background for the large lettering that announces the baby's name. Contrast is achieved with the size and weight of the lettering styles. The border is an integral part of the design, providing a creative way of relaying important information to the reader.

Accents and punctuation

Here are some accents so that you can use the alphabets in this book to write words in different languages. There are also some common punctuation marks. Indicated next to each set of marks are the alphabets they are designed to be used with.

Weddings

**Copperplate and
Copperplate capitals**
(pages 26–29)

**Alfresco and Alfresco
capitals** (pages 32–35)

**Gothic and Gothic
capitals** (pages 38–41)

Holidays

Greetings
(pages 46–47)

**Sweetheart and Sweetheart
capitals** (pages 50–53)

Phantom (pages 56–57)

Birthdays

Junior
(pages 62–63)

Quipster
(pages 66–67)

Jargon and Jargon
capitals (pages 70–73)

Milestones

Baby Steps and
Baby Steps capitals
(pages 78–81)

Timeless and Timeless
capitals (pages 84–87)

Italic and Italic
capitals (pages 90–93)

Arch In a lowercase letter, the curved portion that attaches to the downstroke.

Archival Conservation-quality materials that will not discolor or disintegrate for generations.

Ascender In a lowercase letter, the portion of the downstroke that extends above the x-height.

Baseline Writing line or guideline on which the letters sit.

Bowl The strokes that form the enclosed area of a letter.

Branching stroke In a lowercase letter, the section that springs up and out from within the downstroke.

Broad-edged tool A tool having a squared-off writing tip with some width; calligraphy pen.

Burnish Rub down for the purpose of adhering. It is advisable to use a cover sheet to avoid putting a sheen on your work.

Calligraphic Refers to letter styles made with a broad-edged writing tool.

Capital An uppercase letter.

Centered Lettering is centered with equal ragged margins on left and right.

Counter space The partially or fully enclosed portion of a letter.

Cursive Text or lettering with joined letters.

Descender In a lowercase letter, the portion of the downstroke that extends below the x-height.

Design element A component of a composition.

Dominant pen angle The pen angle used most often for a particular alphabet (see also Pen angle).

Double stroke Two parallel strokes made with the same or different-sized tools.

Downstroke A stroke made when the tool is moved from top to bottom.

Ductus The direction and order of the strokes that form a letter.

Entry stroke The first mark the pen makes when beginning a letter.

Ephemera Things intended for short-term enjoyment; not archival.

Exit stroke The last mark the pen makes when finishing a letter.

Flourish A decorative addition to a letter that extends beyond the letter shape.

Flush Lettering aligns to a single straight margin on either left or right; the other margin is ragged.

Gouache An opaque, water-based pigmented paint that comes in a wide range of colors. Refer to manufacturer's information for quality and permanence ratings.

Guidelines Temporary lines ruled to assist in making consistently sized letters in a straight line.

Gum arabic A binder used in gouache and watercolor paints. A drop or two can be added to paint so that lettering does not smudge when guidelines are erased.

Hairline serif The thinnest entry or exit stroke a pen can make.

Hook serif An entry or exit stroke that looks as if it is cupping a portion of a very small circle.

Interlinear The space between lines of writing.

Justification The side to which the text aligns. Text can be left, right, or left and right justified. It can also be justified around the shape of another element.

Kick-leg The lower diagonal stroke of K or R.

Letter slant The forward tilt of an alphabet; 0 degrees is considered to be upright.

Lightfast Retains its original color when exposed to daylight over a period of time. Artist-quality materials are rated for lightfastness.

Lowercase Letters, often with ascenders and descenders, that are used to accompany capitals; also called minuscules.

Majuscules Uppercase or capital letters (A, B, C).

Minuscules Lowercase letters (a, b, c).

Mock-up A scale model or sketch to determine the layout and structure of a composition or card.

Monocase A complete alphabet that does not have separate upper and lower cases.

Monoline A tool or letter form with a single line width; without thicks and thins.

Mountain Relating to folds; the protruding side of the fold.

Nib widths Used to determine the x-height, ascender, and descender of calligraphic alphabets.

Pen angle (flat, steepen) The angle of the broad-edged pen nib relative to the baseline. A flat pen angle (0 degrees) is parallel to the baseline. As you rotate the pen counterclockwise, the pen angle steepens. A change in pen angle is sometimes necessary to make strokes of correct weight or thickness.

Pen manipulation While writing, the broad-edged pen is rotated between the thumb and forefinger in order to vary the width of the stroke.

Permanent Can refer to lightfast or waterproof writing fluid in a pen or marker.

Pigmented Refers to the quality of the color source used in writing fluid; usually means it is lightfast.

Pressure Deliberate stress applied to the writing tool and against the writing surface to make a thicker stroke.

Prototype A sample made to scale from the chosen materials.

Retrace Go over the same line or stroke again with the writing tool.

Sans serif Without visible entry and exit strokes.

Serif An entry or exit stroke.

Stamp Leave an impression by pressing an inked object against the paper surface.

Stroke A section of a letter made without lifting the writing tool off the paper.

Thicks and thins Contrasting line widths within a letter; usually in reference to calligraphy.

Tone The value of a color as it relates to light and dark.

Tooth serif A short, tapered, manipulated stroke that hangs down from the tops of letters C, E, F, G, and S.

Uppercase Capital or majuscule letters.

Upright A stroke made at a 0-degree letter slant.

Valley Relating to folds; the indented side of the fold.

Verticals Downstrokes on the same slant as the alphabet.

x-height The height of the body of a lowercase letter, excluding ascenders and descenders.

Index

Credits and resources

Dedication

This book is dedicated to my Mum who, for many years, sent personal cards and letters to those who were isolated, ill, or otherwise unable to participate in community activities. Her encouragement and good cheer will be missed.

Author's acknowledgments

Thank you to all the calligraphers and lettering artists who responded generously with beautiful samples for the gallery pages. The international calligraphic community is terrific. Special thanks to Diannah Benson for allowing me to use her beautiful Copperplate exemplars for this book.

I am truly grateful for the sustaining love and patience of my husband David and our children Hilary and Taylor. In addition, I cannot express well enough the deep appreciation I have for the small group of fellow artists whom I have also come to love. Linda, Lynn, Cherri, and Carol: your encouragement, inspiration, and support are immeasurable.

Picture credits

Quarto would like to thank Lynne Watterson for preparing step-by-step and finished examples for the core techniques chapter. We would also like to acknowledge the following copyright holders for providing illustrations and finished examples. All images are referenced by the main page on which they appear.

Key: t top; b bottom; l left; r right; c center

Ruth Booth: 30 (blue flower border); 36 (butterflies, solid oak leaf, purple and yellow flower border); 37 (blue bouquet, grasses); 42 (black border); 43 (stained glass); 48 (tree border using punch); 49 (wreath, inner row of fairy lights); 54 (bottom three borders); 55 (blazing heart);

59 (Jack-o'-lantern); 64 (candle border); 74 (gift border); 88 (heart-and-vine border); 89 (touching hearts); 94 (calligraphic borders); 107 (wet media); 108 (decorated capitals)

boothprussick design (Ruth Booth and Linda Prussick): 30 (rose border); 37 (daisy bouquet, rose arbor); 43 (lily); 58 (mummy, Jack-o'-lantern border)

Lynn Lefler: 55 (watercolor rose)

Rubber stamp motifs: Magenta 36 (dragonflies) & 77c (purple heart); Heather's Stamping Haven 43 (green tile); Sunshine Designs 48 (snowmen); Great Impressions 75 (butterfly) & 83 (chick)

Shutterstock: /Leo Blanchette 1, 2; /Daniel Radicevic 22, 96; /Dawn Hudson 30tr; /Holly Jones 37 (cake); /Elisanth 42bl & br; /Gilmanshin 42bc; /Brook Johnson 58 (confetti); /Khrameshina Tatiana 59 (large spider); /fat_fa_tin 64 (ladybugs border); /Tammy Sillstrop 64 (party hats border); /Kar 65 (clown); /tillydesign 74tr; /Siobodan Djajic 74b; /Ahmed Abusamra 75tr; /Purematterian 75cr; /Syba 89bl; /Jut 89bc; /Princess Lola 94tr

Gallery (pages 114–121): Ruth Booth (www.letteringsolutions.com); boothprussick design/ Ruth Booth and Linda Prussick (www.boothprussick.com); Michael Clark; Julie Gray; Eliza S. Holliday (www.letterist.com); Lynn Lefler; Mark Lurz; Cherryl Moote (www.mootepoints.com); Linda Prussick; Lily Yee

All photographs and additional illustrations are the copyright of Quarto Publishing plc. While every effort has been made to credit contributors, Quarto would like to apologize should there have been any omissions or errors—and would be pleased to make the appropriate correction for future editions of the book.

Resources

All of the tools and materials used in this book should be readily available from your nearest arts and crafts store. In addition, below is a selection of Web sites where you can explore the options available. Many Web sites either allow you to order directly (and ship internationally) or list stores where their products are available. Clip art Web sites are great sources of borders and motifs that can usually be downloaded for a small fee. The majority of the three-dimensional embellishments featured in this book were sourced from Handy Hippo and QuickKutz.

www.annagriffin.com
www.benfranklinstores.com
www.bookmakerscatalog.com
www.craftsetc.com
www.currys.com
www.dickblick.com
www.doverpublications.com
www.greatimpressionsstamps.com
www.handyhippo.co.uk
www.heathersstamping.com
www.hobbylobby.com
www.iclipart.com
www.japanesepaperplace.com
www.johnnealbooks.com
www.loomisartstore.com
www.luckysquirrel.com
www.magentastyle.com
www.michaels.com
www.paperinkarts.com
www.quickutz.com
www.shutterstock.com
www.stampin.com
www.stampington.com
www.sunshinedesigns.ca
www.talasonline.com
www.uchida.com